Victorian &
Edwardian
Surrey

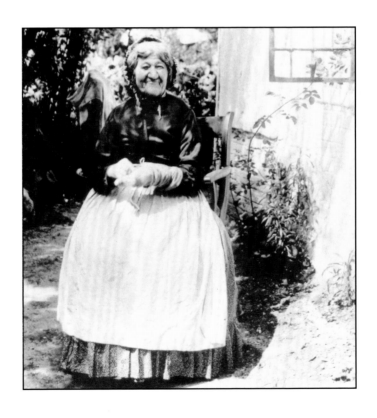

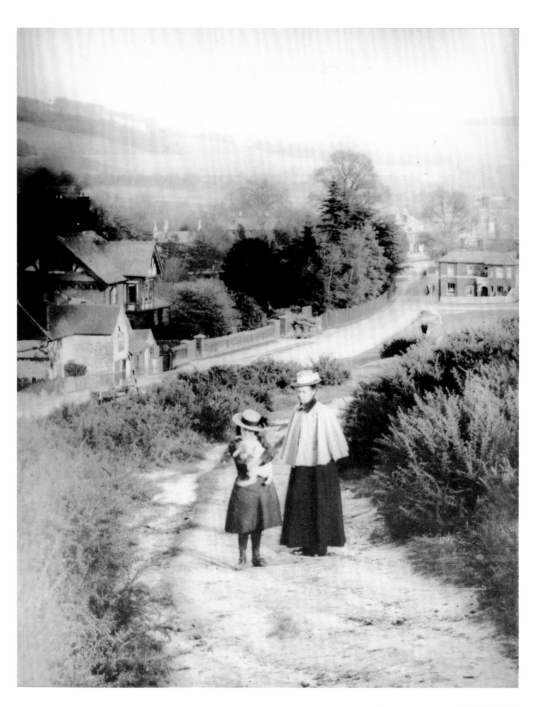

WESTCOTT

Victorian &
Edwardian
Surrey

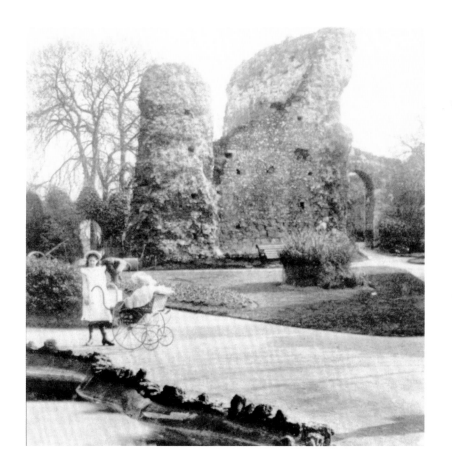

Aylwin Guilmant

AMBERLEY

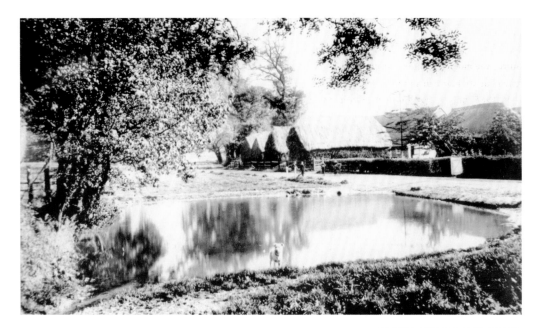

ALBURY FARM AND POND

First published 1993 under the title *Surrey of 100 Years Ago*
This revised edition first published 2008

Amberley Publishing
Cirencester Road, Chalford,
Stroud, Gloucestershire, GL6 8PE

British Library Cataloguing in Publication Data.
A catalogue record for this book is available from the British Library.

ISBN 978-1-84868-023-4

Typesetting and origination by Amberley Publishing
Printed in Great Britain by Amberley Publishing

The Surrey of this book is the county as it existed before the London Government Act of 1889. It measured approximately 40 miles from east to west and 24 miles from north to south. The River Thames was its northern boundary and afforded it an outlet to the sea. The creation of London County Council in 1889 removed from Surrey the modern London Boroughs of Lambeth, Southwark and Wandsworth. In the same year Croydon was given county borough status.

In 1965, on the creation of the Greater London Council, the new London Boroughs of Croydon, Kingston-upon-Thames, Merton, Richmond-upon-Thames and Sutton were formed, in whole or in part from towns formerly in Surrey, and it is interesting to note that these same towns jealously preserve the name of the County of Surrey in their postal addresses. At the same time Staines and Sunbury, which now form the Borough of Spelthorne, were transferred to Surrey from the former county of Middlesex. When Kingston-upon-Thames was taken over by London it created the anomaly that Surrey County Council offices were outside the county. This artificial partitioning, with County Hall at Kingston-upon-Thames and Surrey Record Offices both there and at Guildford, has led over the years to much confusion.

This book attempts to include many of the aforementioned towns close to the metropolis as well as towns and villages in the countryside to the south and west. Towards the end of the nineteenth century many aspects of life in the remoter parts of Surrey had remained unchanged for generations; rural communities still retained their individual characteristics and dialects peculiar to themselves. Those areas around London were a separate entity and had little in common with the rest of Surrey.

We are fortunate today that a record of this period has been preserved in the writings of local authors and others who lived in and loved the Surrey of this book. During the nineteenth century Surrey became the adopted home of many famous writers, some of whom used the county as a setting for their novels. Eric Parker, who in his youth travelled extensively, wrote fully of his many amusing experiences in the Highways and Byways in Surrey. Denham Jordan, writing under the pseudonym 'Son of the Marshes', lived for a time near Dorking where he wrote his observations of the countryside and its peoples. Gertrude Jekyll wrote fully on many aspects of Surrey life, while George Sturt (who also wrote under the name of Bourne), Farnham born and bred, wrote of his childhood and early working life in his father's wheelwright's shop. Musicians and artists have also settled in Surrey and it may well be that the beauty of the scenery has proved an inspiration for their work.

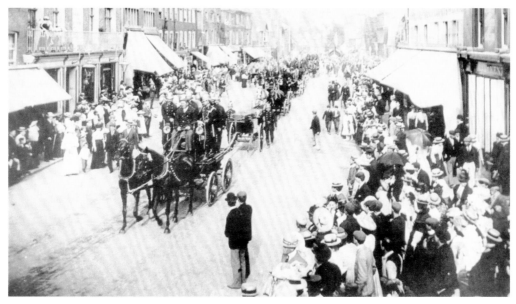

STAINES HIGH STREET

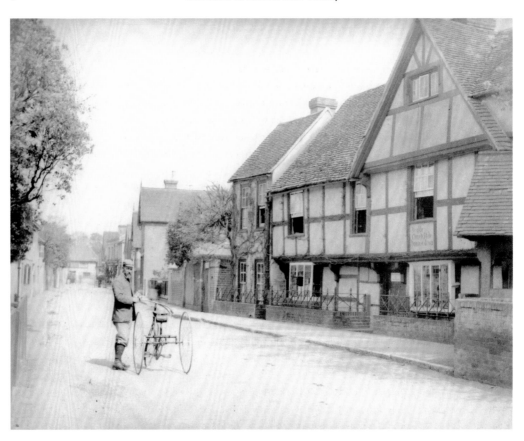

CHURCH STILE HOUSE, COBHAM

In the past many books have appeared describing all aspects of Surrey: the picturesque scenery, local customs, places of historical interest and sleepy villages, and it is from these pages that the text has been taken, linked with pictures of my choice. I would add that I have deliberately refrained from including famous landmarks and famous people.

The distinction between rural and metropolitan Surrey at the turn of the century was often its great attraction. As Mrs Arthur Bell, writing c. 1900, commented, 'there is hardly a suburb without its memory, they [the suburbs] are the homes of all those statesmen, courtiers, men of the world and men of study, who love the country, but to whom the business and pleasure of the Society of London was needful'. Richard Jefferies was one who recognized that even the Londoner could appreciate the countryside of Kew Gardens on his doorstep.

Life in Surrey during the nineteenth century was very different from today. Men and women took pride in their work, however menial, while industrialists such as Mr George Miller of Mitcham supported his workforce. Children knew their place in society and accepted the authority of parent and teacher without question. The word of the elderly carried weight and again they were given due recognition. In many ways life was not only simpler but also much more pleasant, as is evidenced from many of the smiling faces caught by the camera.

Surrey is one of the smallest counties in England, and is virtually two counties in one—the London suburbs now known as the London Boroughs and the countryside loved by Gertrude Jekyll. As early as 1908 Eric Parker stated that 'almost ten miles south of the River Thames the old countryside had disappeared', and this might have become true for the rest of the county but for the timely intervention and concept of the Metropolitan Green Belt which safeguarded much of it from being swallowed up by an ever expanding London.

In the late nineteenth century the county had on its northern boundary the River Thames, with Bermondsey and Rotherhithe the centres of trade; today the name 'Surrey Docks' has almost disappeared from our history and the royal dockyard at Deptford is but a memory. On the western boundaries are Berkshire and Hampshire, and to the south and east Sussex and Kent. It is with the latter two that the rural areas of Surrey have much in common, not least the common boundaries of the Downs and the Wealden forest. There is also a similarity between dialects and words used by the rural inhabitants.

The name 'Surrey' is believed to have originated during the Saxon period, and it is thought to mean 'south region', but no written evidence exists to corroborate this statement. Evidence does exist, however, to substantiate the claim that early man inhabited certain regions of Surrey at least 500,000 years ago; but it is not until 3,000 BC, when he left recognizable earthworks in the landscape, that these early Neolithic people, with their basic skills in agriculture, flint mining and trade, can be more fully documented. Today, one of their early tracks, subsequently known as the Pilgrims' Way, is still evident along the chalk escarpment. Among the early remains still to be seen are Caesar's Camp on Wimbledon Common (an Iron-Age fort), Celtic fields on Farthing Down and Saxon burial barrows above Coulsdon.

Surrey, like its near neighbour Sussex, was during the Roman occupation divided into tribal territories of the Regni, with the administrative capital at Noviomagus Regnum, or, as it is known today, Chichester. It was at this time that London was founded, and its closeness to this important centre proved a considerable asset to the county, particularly in the development of a major road system, the earliest through Surrey being the Calleva Atrebatum running from London to Silchester and Bath, and also that of Stane Street, which went from London to Chichester. The convergence of Stane Street and Watling Street was at a bridgehead settlement on the south or Surrey bank of the River Thames. It is believed that through its close proximity to London the county first developed as a

DEERLEAP WOODS, WOTTON

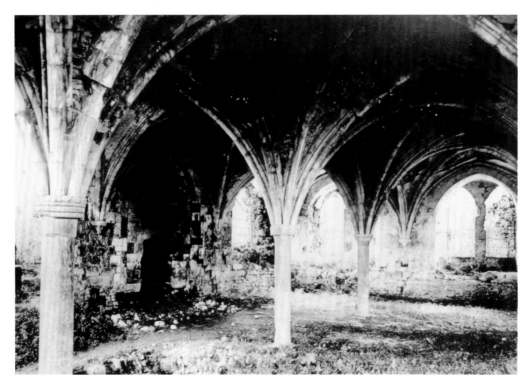

WAVERLEY ABBEY RUINS

'workshop' with small industries along the banks of the rivers, particularly the Wandle, while those settlements nearest to London naturally expanded in importance as producers of food and consumable goods.

The Saxons first settled in the valleys around the Surrey rivers, particularly the Wandle, Wey and Mole. Saxon kings were subsequently crowned at Kingston-upon-Thames, thus beginning a long tradition within the royal borough. The Weald, stretching across much of the south-east of England, proved at first a natural barrier, and there was little cultivation or penetration beyond the perimeters, and only the swineherder and cattle-drover ventured within this inhospitable region. However, settlements with names ending in 'ley' are considered to be the result of Saxon woodland clearance, and by the time of Domesday eleven such settlements were recorded. Life evolved around these scattered farms and settlements which in time developed into small villages. The chief town during the Saxon domination was (as in Roman times) Southwark, close to London, and mentioned in the tenth century Burghal Hidage as a defensive area against the bands of marauding Danes.

With the coming of the Normans, who drew up the Domesday Book of 1086, we have a clearer picture of a scantily peopled countryside. According to Brandon the 'single farms carved out of the waste in the early middle ages were progressively improved by each succeeding generation'. Guildford expanded from a Saxon royal manor through a flourishing cloth industry and the patronage of Henry III and Edward I. Monks from Normandy settled in Surrey and founded their religious houses, one of the earliest being Waverley Abbey situated on the River Wey, close to Farnham; another was the Cluniac abbey of Bermondsey, founded in 1082. The abbey of St Peter of Chertsey, the oldest religious house in Surrey, was sacked in the late ninth century, but regained its position and became one of the largest and most influential of the English monasteries.

In 1215 King John was forced to sign the Magna Carta in the historic fields at Runnymeade. In the following century many Surrey labourers took part in the Peasants' Revolt of 1381, and again they became followers of Jack Cade in his rebellion of 1450, along with their fellow countrymen from the adjoining counties of Kent and Sussex.

Surrey was by the fourteenth century 'a land of gardens', due in some measure to the well-stocked manor gardens and the popularity of cider as a beverage. The spread of apple orchards coincided with the demand for charcoal and timber for use in the naval dockyards and also in the building of London and its suburbs. Many

trees were planted in the Surrey countryside, and remain a feature of the landscape today; while Surrey churches are distinguished by the amount of timber used in their construction.

Despite the small size of the county, its soils are most varied; many, however, are of poor quality and for much of the medieval period agriculture was primitive, while the transport system was almost non-existent between many of the outlying settlements. The farmers of this period relied to a great extent on marl to manure the poorer quality land, and those close to lime pits were therefore in a more favourable position, it was not, however, until the seventeenth century that the latter was used in any great measure, due in the main to the difficulty In transportation. Each little settlement became self-sufficient, and for four centuries these isolated communities were little changed.

Surrey further developed as a 'workshop' during the sixteenth and seventeenth centuries. This was mentioned by John Evelyn, the well-known diarist, when every stream and river was the site of a mill turning out a wide variety of goods from brass to corn.

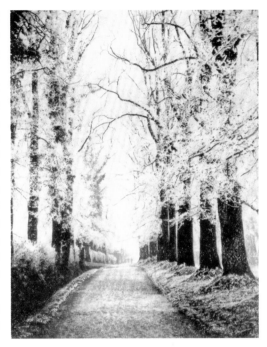

A SURREY LANE

Evelyn was a native of Surrey and like his countryman William Cobbett, two centuries later, travelled extensively recording in his *Diary*, his impressions of the county. Due to their close proximity to the London markets, Surrey farmers planted more extensively, and naturally benefited from this increase in agricultural production. With their added wealth farmhouses were improved and renovated, while large houses for the nobility were erected. The King himself set an example with work on Nonsuch Palace and Oatlands and the laying out of the gardens at Hampton Court Palace in the fashionable 'French' style.

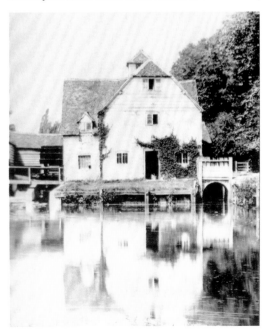

A PEACEFUL MILLSTREAM

While life at this time became considerably more comfortable for the more wealthy members of the population, both rich and poor alike were subject to the harsh realities of various epidemics which periodically swept through the county, striking particularly in the more densely populated areas. Dorking suffered severely from an outbreak of the plague in 1603, while Bermondsey and Mortlake suffered from epidemics during the sixteenth and seventeenth Centuries.

As with other parts of the south-east, Surrey suffered from the vicissitudes of the war between Parliamentary forces and the Royalists; certain towns were more involved than others, including both Farnham and Guildford. Farnham castle changed hands on a number of occasions. However, it is believed that perhaps Kingston-upon-Thames was the most vulnerable, situated as it was close to the Royalist quarters at Windsor. The county in the main favoured the Parliamentarians, but this in no way

affected it at the Restoration, when many wealthy London merchants bought houses there, and the city gradually encroached on the countryside.

It was in the seventeenth century that Epsom first developed as a spa, but its popularity was brief. The one constant factor which kept the countryside from developing too rapidly was the bad state of the roads: the *nouveaux riches* could only live in their newly acquired properties during the summer months, and by autumn all visitors had left Epsom. However, it was not until the mid-eighteenth century that these deficiencies were acknowledged to be a considerable obstacle to economic advancement. The seaside resorts were becoming popular, and, with Portsmouth the main naval base, it was deemed necessary to upgrade the road network; the various turnpike trusts competed with one another to this end. Within a century a whole new road system came into operation with a direct link from London to the south coast and improved cross-country connections.

The Wandle valley was one of the most industrialized districts in England and in 1802 the Grand Surrey Iron Railway was built from a wharf at Wandsworth. Shortly afterwards in 1816 the Wey & Arun Canal opened; despite linking London and the south coast the canal was never a viable proposition and only lasted a mere fifty-five years, ultimately losing trade to the burgeoning railway network which criss-crossed the county. This brought in its wake the first of the commuters who worked in the city and, because of the clean country air, preferred to raise their families in Surrey, a fashion which has extended into the twentieth century.

William Cobbett, born in 1762, travelled throughout the Surrey countryside, recording for posterity the way of life of those living in the county. Cobbett was a keen observer and early noted the introduction of the newcomer into the countryside, buying up properties and remodelling the landscape, so that much of what one sees today is man-made. Cobbett believed that the new gentry usurped the yeoman and that rural life as lived by his ancestors was fast disappearing. However, there were many Surrey farmers who disagreed with his viewpoint, some indeed who preferred to leave Surrey for a new life in America where they were not hampered by outmoded methods of agriculture. With the new improved turnpikes many farmers were able to branch out with more varied crops, and within the Weald in particular much land that had previously been used for stock-rearing now grew grain. While it was necessary to manure much of this land, chalk from the many quarries was transported both by

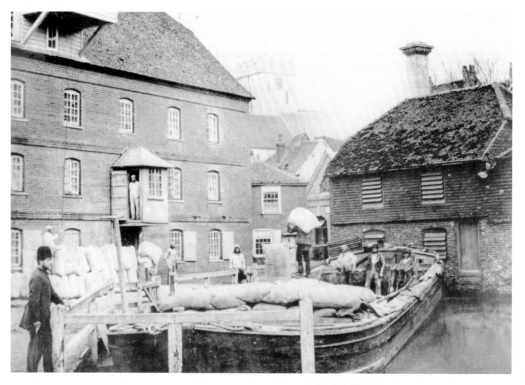

BARGE AT TOWN MILLS, GUILDFORD

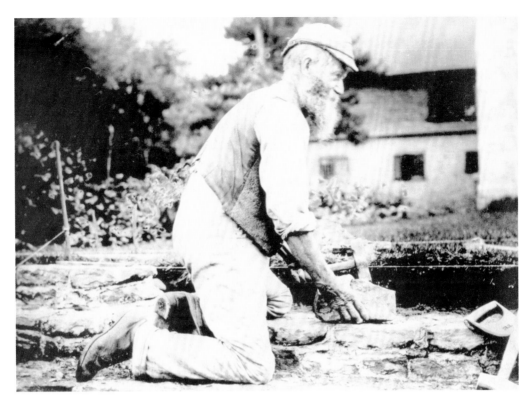

THE OLD BRICKLAYER

road and rail, and most of the Surrey farmers on acidic land had their own lime kilns for the production of this valuable and necessary manure. However, even as late as the mid-nineteenth century criticism was raised against the backward state of Surrey agriculture.

It is interesting to note that later in the century ordinary men of the labouring class were still complaining of the red brick villas being built on the Surrey hills and the loss of their old 'measters' and local squires. Many of these new estates were remodelled in the informal style founded by 'Capability' Brown and Humphrey Repton. Surrey was so popular with those working in London that many of the city businessmen acquired farmhouses which they proceeded to remodel in the fashion of the times. Many of the small market towns prospered from the introduction of new found wealth, while others grew along the railway network, and the London suburbs continued to reach out into the fast diminishing countryside. Industries flourished along the banks of the Surrey rivers, however there was little industrial development within the countryside. The growing demand for land continued to inflate prices and it is believed that the speculative builder was responsible for completely altering the face of the countryside within a very short period of time. Fortunately this period coincided with the inception of the National Trust who did much to acquire control of well-known beauty spots and other large areas.

It was towards the end of the nineteenth century that a survey and photographic record was first envisaged, and this went some way towards stemming the further loss and disfiguration of many of the old farmhouses and other traditional buildings, among them the various mills which had for so long been a feature of rural life. In 1980 The Surrey Historic Building Trust was formed to preserve historical buildings, gardens, land and machinery; District Councils and voluntary bodies supported this work.

The population of Surrey increased by more than a quarter between the wars and the built-up area extended almost unbroken south as far as Caterham. David Robinson, the County Archivist, writing in 1989, said, 'the County Council's initiative in town and country planning was of immense importance in the long term'.

Surrey now has the two major airports of Heathrow and Gatwick on its boundaries, which has led to an increase in road traffic both in and through the county. Together with the construction of new motorways and the London 'orbital', this has further increased the pressure on the countryside.

Since the end of the Second World War light industry has developed in the county, many of the firms previously in the inner and suburban areas of London having deployed elsewhere. In the 1960s the population of metropolitan Surrey had reached its peak, ten years later it had fortunately stabilized, but not before certainty of the Surrey towns were in danger of becoming one huge conurbation and a planner's nightmare. Due to good management this has been avoided.

Today the County of Surrey is fortunate to have men of vision, who have built a new cathedral at Guildford and sited the university there, and also enhanced the good life for resident and visitor alike to experience the pleasures of an earlier and simpler age linked with modern facilities. The future for Surrey in the twenty-first century looks optimistic in that Surrey still retains much that is good of its past.

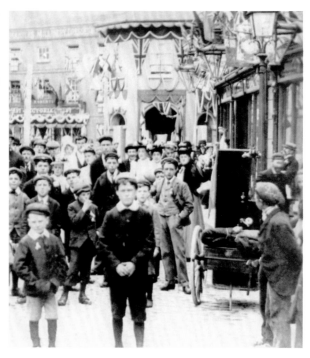

QUEEN VICTORIA'S DIAMOND JUBILEE
CELEBRATIONS, GODALMING

FISHING BELOW LEATHERHEAD BRIDGE

Victorian
& Edwardian
Surrey

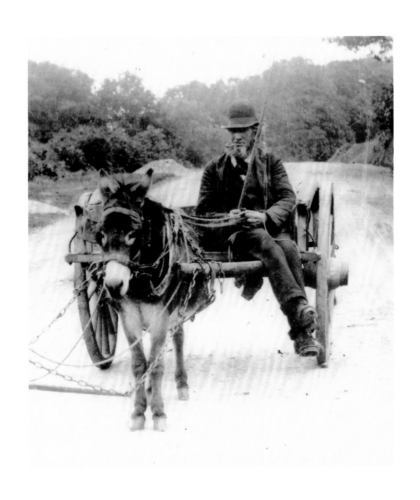

THE CELEBRATED
DORKING SAUCE,

For Game, Chops, Hashes, Hot and Cold Meat, Fish, Soups, Gravies, Curries, &c.

This delicious Condiment, which possesses a peculiar and agreeable piquancy, is, from the superiority of its zest, more generally useful than any other yet introduced, and is besides, from its valuable stomachic qualities, greatly calculated to facilitate digestion.

Prepared only by

E. & F. DURANT, LATE HARRISON,
Chemists, Dorking,

And may be obtained of all respectable Chemists and Grocers throughout the Kingdom.

PRICE ONE SHILLING.

GEORGE WICKS,
TOWN CRIER, DORKING,
SURGEON TO THE
PARASOL & UMBRELLA HOSPITAL.

Broken Bones carefully set, Joints neatly mended, in fact the whole Frame undergoing a speedy restoration, in less than twenty-four hours.

N. B. German, French, English. and Italian Patients taken in, and attended to daily by a Native.

The road throughout this walk leads on through woodland and common, by paths bordered with fir trees, or passing over hills beneath which a great part of the wealds of Surrey and Sussex lie extended before the traveller. By far the larger proportion of the land through which he must pass is uncultivated. Considering the small size of the county of Surrey, the extent of it which lies a mere wilderness in these busy days is simply amazing. The whole county is but twenty-seven miles in length, and not more than forty in breadth, yet it contains almost every variety of scenery, scarcely one mile is like another, and often the whole character of the country undergoes an utter change within the space of half a dozen miles. Where out of Scotland can be found such moors and heaths as those between Thursley and Hindhead, or even between Albury and Ewhurst? Many of the commons or downs are familiar to excursionists, but the heaths in the more distant and neglected parts of the county are little visited. The cottagers to be met with here and there will tell you that they scarcely ever see a stranger from one year's end to another.

Louis Jennings

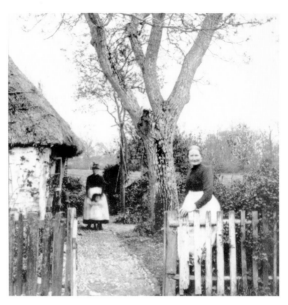

COTTAGERS

CRANLEIGH

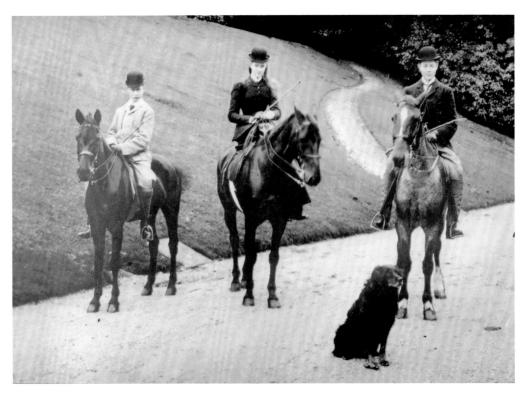

YOUNG RIDERS

UNDER THE NORTH DOWNS

So wooded are these lofty hills, so rustic their every bend and fold, and of so wondrous a fertility their bounteous soil, that, were it not for the established fact of mere distance from London lending the west country an additional charm, one would dare to compare this district with South Devon itself. Its actual merits are equal; its distance from town less than thirty miles, as compared with two hundred. But beyond compare are its old cottages, the red brick and timbered farmsteads, and the ancient manor-houses of this corner of Surrey, whose ruddy walls, or green and lichened roofs, exercise the palettes and the pencils of artists innumerable. Surrey farmhouses have their likeness nowhere else, and in no other county shall you seek with equal certainty of success these characteristics, or those clustered chimneys that make every humble home of these valley roads and sequestered by-lanes an old-world mansion, dignified and reposeful.

It could be very persuasively argued, if need were, apropos of the title of this paper, that no one should climb hills if he would keep a proper respect for them. Let the valleys be easefully pedalled and exertion saved, and the fine sense of mystery and the illimitable which hilltops give, whether wreathed in mists or bathed in sunlight, be at the same time preserved. When you climb a hill you know its limits. You know, as a result of your exploration, every minor feature of it, and thus, fully informed, have of necessity something of that contempt engendered by familiarity. Thus are the easefully inclined excused of their easefulness. Not for such the toilsome climb—to discover that the grass of the hilltop is merely the grass of the valley, only of less luxuriant growth. 'All is vanity and vexation of spirit,' said the Preacher. He has probably climbed the hilltops and become disillusioned. Thus it is to be an explorer! Why, even those stalwarts who have climbed Parnassus have found the empyrean something too thin, and the grass of those heights not so much rare as rank. Happy, then, those who are content with the level lands, and regard the uplands from that safe and comfortable vantage-point. They keep their illusions, and if they be imaginative there is no reason why lions and tigers, eagles and other fearful wild-fowl, should not inhabit the North Downs, instead of the rabbits and the song-birds that reward the explorer's gaze.

Charles G. Harper

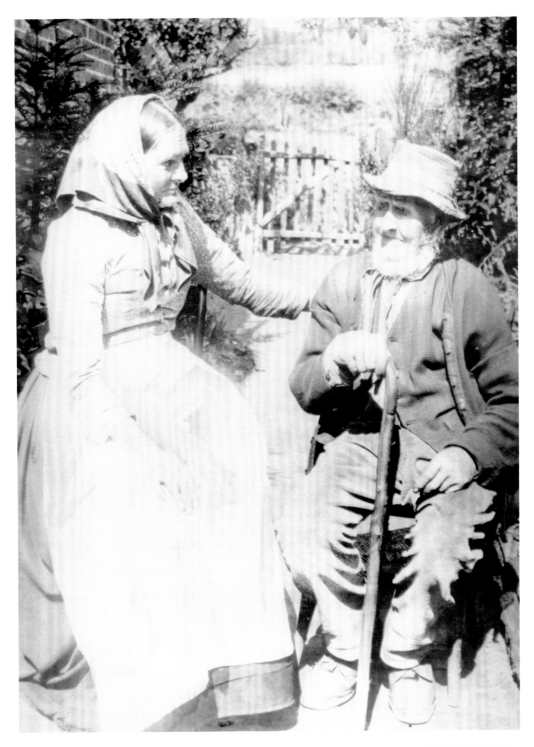

TWO'S COMPANY

LEADING THE WAY

COUNTRY WAYS

In the hillside village, lying remote from railway stations, you get the real Surrey accent, unvulgarised by the cockney. You hear the carter call out 'Gee—whut-ah' to his horse, the ploughman bidding his team to 'mither-wee' when he wants them to come round to him. That flies do 'tarrify' is a common expression amongst shepherds and stockmen. Even amongst educated men—that is, men who are of long pedigree of the soil—the ewe is still a 'yow', sheep are 'ship', and to fallow is to 'foller', at any rate when speaking to their shepherds and ploughmen. Bush-harrowing the meadow is called 'sweeping'; 'stan'ard' is probably called out to the loader of the hay-waggon by the student of Wye College, dropping the aspirate without even a shudder.

'Slummacking sort of a way' is very expressive, though when labourers call earth 'dirt' one feels there is a loss of dignity, though contempt is not implied.

I once employed a labourer fond of horses who complained that diggin' had no life in it—it was dead work; and I employed another man who was romantic enough to find 'fivers' in the earth—of course he meant fibrous roots. A gate is always a 'geat', and a trough is always a 'tro'.

I knew a man in one village who finds much work to be a 'servitude', an expressive word for irksome labour, but then he was noted for his choice diction. Barbed wire is always 'gagged wire', which I think is rather nice; and a brush broom at the door for the rubbing against of dirty boots is a 'Tom Paine', which gives us an insight into the frightful bigotry and early Victorian view of that man of great heart.

The big muscles of one's body are called 'leaders', and a drought is a 'dre-ert'.

Mrs Jekyll relates how a man in doing business was warned thus: 'So you're gwine to buy a pony off Master D, be you? Well, you'd better take care how you deal with he: *he's a very religious man.*' This reminds me of a farmer who once complained to me that the saddler, a faithful attendant at chapel, 'charged for his gospel in his dratted bill'.

Irony is not understood, though sarcasm is often well appreciated. Restraint rather than extravagance is the touchstone of peasant speech. 'A few' is really many, and 'several', or 'a tidy few' a great many.

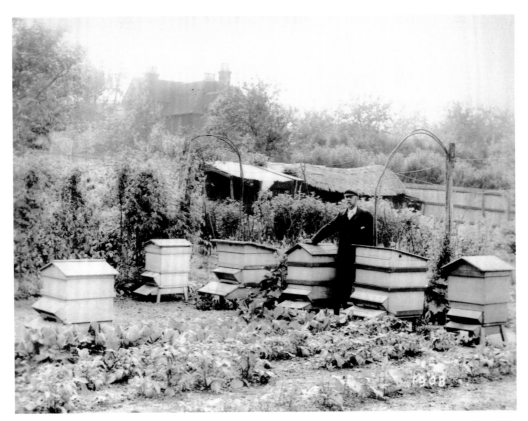

BEEHIVES, WESTCOTT

Bucolic humour of a practical kind was once displayed towards me when I was looking at some bee-hives at a farm sale. A keen bee-keeper, looking upon me as a dangerous competitor, clumsily bumped up against the hives, hoping thereby the enraged bees would come out and sting me, and so cool my ardour as a bidder. Unfortunately for him, he got the stings, and had to fly, pursued by angry bees, whilst I remained scatheless.

A farm sale often reveals delightful old cottage furniture and archaic farm tools. There is something which takes us into the mysteries of rural technique when we see 'a wimble, two faghooks, a peaswop, and a jet' catalogued as one item.

It is when a catalogue describes a number of pedigree stock that the greatest interest is evoked. It is really extraordinary the amount of interest taken in live stock by intellectual men who indulge in farming. I know, for instance, a successful lawyer, for whose knowledge of philosophy and law I have a profound admiration, who will spend the best part of his Sundays gazing with admiration at his pedigree Berkshire and Yorkshire pigs. The smell of his piggery is more alluring to him that the incense of his church. His passion for his swine is undisguised, and if he meets you along the lane near his piggery, he will insist upon you going the whole hog with him.

Taking life on the whole more gravely than the townsman, the countryman's sense of humour is different. A solicitor who returned to live in my village had been singing what he thought was a comic song. One verse ended in the statement that the best place for the subject of the song, after getting his head cracked, was the House of Commons, 'where no brains are needed'. Much to the singer's astonishment, several listeners, who had hitherto been very friendly, refused to speak to him afterwards. Sadly he learnt the reason of the animosity of these men. They—farmer, blacksmith, and publican—had just been elected to the Parish Council, and regarded the references to members of Parliament as personal to them as parish councillors!

F. E. Green

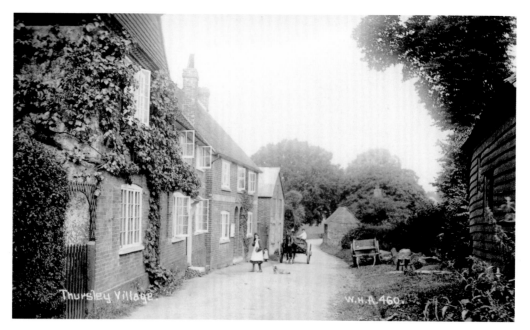

THURSLEY VILLAGE

AS LEGEND HAS IT

In a county such as Surrey, possessed of an ancient civilization and strongly marked physical features, it would be remarkable if no traces of early religions and superstitions remained in place-names and local traditions.

As a matter of fact in the place-names of Surrey we have some most interesting traces of the worship formerly paid to Celtic and Scandinavian deities, although almost every other indication of the cult has long since perished. Sites dedicated to the worship of Taith are indicated by such names as Toot Hill, Tooters Hill, etc., and Surrey possesses an instance of an almost identical character in Tooting. It is to be observed, however, that in this case it is not a hill, or a single site which bears evidence of the Celtic deity, but a settlement or a district inhabited by people professing that ancient faith. Of the worship of Odin, or Woden, remarkably clear evidence is afforded by such names as Woden Hill (Bagshot) and Wanborough situated under the north slope of the Hog's Back, and possessing springs which, tradition states, have never been frozen. Wandsworth, too, derives its name from a river which was probably named after this deity. Thursley, Thundersfield, and Thunderhill, serve to remind us of the ancient Scandinavian Thor and the Anglo-Saxon form of his name, Thunor.

It is worthy of notice that three singular mounds on Frensham Common, in the vicinity of Thursley, are known as the 'Devil's jumps', and an extraordinary glen in the same neighbourhood is called the 'Devil's Punchbowl'. In the application of these names there is something peculiarly suggestive of the ancient Scandinavian legends of Thor's gargantuan exploits in lowering the level of the sea itself to prove the extent of his bibulous capabilities.

In many parts of the county popular tradition ascribes to Satanic influence works which do not appear at first sight capable of easy explanation. In certain cases, for instance, where an ancient church is situated at some distance from the village street, or that part of the village which is most thickly populated, a favourite explanation of the circumstance is that, whilst men proposed to build their church near their houses, the Devil, for some sinister purpose, removed their work to a distance during the night. A curious tradition lingers at Guildford relative to the building of the chapels of St Martha and St Catherine. Two sisters are credited with the building of these two edifices, and it is said that they were in the habit of flinging the hammer backwards and forwards to each other as they required it.

Godstone, in Surrey, like Godshill, Godstow, and similarly-named places in other counties, was probably a pagan site consecrated to Christian worship.

George Clinch

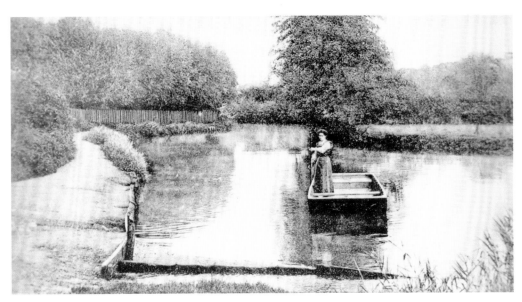

ST CATHERINE'S FERRY, GUILDFORD

ST CATHERINE'S FERRY

When we had passed through the hollow to the north of a few cottages, direct evidence of the road disappeared at the boundary of Monk's Hatch Park, but it was not lost for long. 350 yards further on, laid on the same line, a slightly sunken way reappeared; it ran a few yards below the recently made Ash Path, and led directly by the lane along the south of Brixbury Wood, across the Compton Road, and so by a lane called 'Sandy Lane', beyond, over the crest of the hill, till, as the descent began, it became metalled, grew wider, and merged at last into the regular highway which makes straight for St Catherine's Hill and the ferry and ford below it.

The Old Road having thus coincided once more with a regular road, we went at a greater pace, observing little of our surroundings (since nothing needed to be discovered), and hoped to make before it was quite dark the passage of the river.

Arrived, however, at that curious platform which supports in such an immense antiquity of consecration the ruins of St Catherine's chapel, we saw that the exact spot at which the river was crossed was not easily to be determined. The doubt does not concern any considerable space. It hesitates between two points on the river, and leaves unmapped about 800 yards of the road; but that gap is, it must be confessed, unsolved so far as our investigation could be carried.

It is certain that the prehistoric road begins again by the north-western corner of the Chantries Wood. Tradition and the unbroken trail hence to St Martha's hill-top confirm it. The arguments I have used in the last few pages show equally that the road led, on this side of the way, up to the point below St Catherine's chapel where we were now standing.

It is, moreover, extremely probable that the platform of St Catherine's was the look-out from which the first users of this track surveyed their opportunities for passing the river, and near to it undoubtedly their successors must have beaten down the road.

The precipitous face towards the stream, the isolation of the summit and its position, commanding a view up and down the valley, render it just such a place as would, by its value for their journeys and their wars, have made it sacred to a tribe; its sanctity during the Middle Ages gives the guess a further credential. But in framing an hypothesis as to how the valley was taken from the descent of St Catherine's to the rise at the Chantries beyond the stream, one is met by two sets of fact irreconcilable with one another, and supporting arguments each, unfortunately, of equal weight. These facts are few, simple, and urgent; they are as follows:—

Primitive man we must imagine chose, if he could, a ford and kept to such a passage rather than to any form of ferry. The ford exists. It has given its name 'The Shallow Ford' to the village which grew up near it. The church

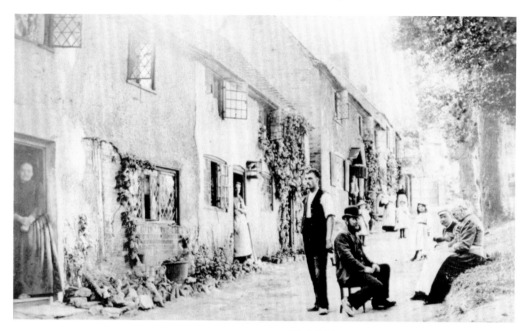

ST CATHERINE'S COTTAGES, GUILDFORD

stands close by. So far it would seem that the road certainly passed over the crest of St Catherine's, came down to the south of that hill, crossed at Shalford, and reached the Chantries by that passage.

On the other hand a sunken way of great antiquity leads directly from St Catherine's Hill down to the river. It follows the only practicable descent of the bank. It is in line with the previous trend of the Old Road; at its foot is a ferry which has had a continuous history at least as old as the pilgrimage, and beyond this ferry, the path over the field, and the avenue beyond the main road, lead immediately and without any diversion to that point at the foot of the Chantries Hill where, as I have said, the Old Road is again evident.

From Shalford no such track is apparent, nor could it be possible for a passage by Shalford to be made, save at the expense of a detour much sharper than the Old Road executes in any other part of its course.

In the face of these alternatives no certain decision could be arrived at. The medieval route was here no guide, for it had already left the road to visit Compton, and was free to use Shalford ford, the ferry, or even Guildford Bridge—all three of which the pilgrims doubtless passed indifferently, for all three were far older than the pilgrimage.

It may be that the ferry stands for an old ford, now deepened. It may be that the passage at Shalford was used first, and soon replaced by that of the ferry. We knew of no discoveries in that immediate neighbourhood which might have helped us to decide; we were compelled, though disappointed, to leave the point open.

It was now quite dark. My companion and I clambered down the hill, stole a boat which lay moored to the bank, and with a walking-stick for an oar painfully traversed the river Wey. When we had landed, we heard, from the further bank, a woman, the owner of the boat, protesting with great violence.

We pleaded our grave necessity; put money in the boat, and then, turning, we followed the marshy path across the field to the highway, and when we reached it, abandoned the Old Road in order to find an inn.

Hilaire Belloc

BUNYAN'S SHALFORD

Shalford Common is wide and breezy; geese cackle over its grass, and you may see more than one cricket match being played on holiday afternoons. Once, in 1877, eleven Mitchells played eleven Heaths on the common; the Heaths were all of the same family, but the Mitchells, though related, were not. But the greatest tradition of Shalford Common is its connection with a Bedfordshire man, John Bunyan. Bunyan is said to have lived in two

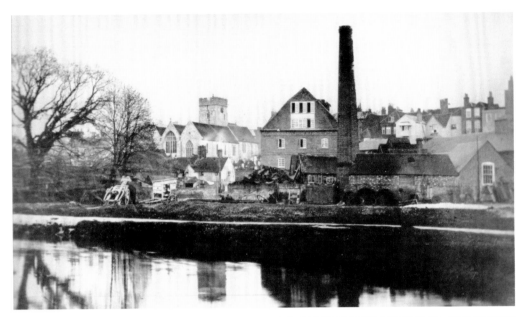

FILMER & MASON'S IRON FOUNDRY, MILLMEAD, GUILDFORD

houses in Surrey, a cottage on Quarry Hill in Guildford, and at Horn Hatch, now pulled down, on Shalford Common. Probably the tradition would not have grown up without good ground; there is one possible reason, at all events, for connecting Bunyan with this part of Surrey. The idea of *Pilgrim's Progress* is said to have been suggested to him by the very Pilgrims' Way, and Vanity Fair to be the fair held on the meadow between Shalford and Guildford below St Catherine's Chapel. The Rector of Shalford had the privilege of holding a fair from the days of King John, and undoubtedly Shalford Fair was one of the largest held on the Way; indeed, it was so popular that the Guildford clergy disputed the Rector's right to exact fees from the Winchester merchants attending it. They wanted the money in Guildford. But the Chief Justice of the King's Bench gave his judgment in the Shalford Rector's favour, and at the height of the fair's prosperity it actually covered a hundred and forty acres of ground. If tradition is right, then, it was in the fields by Shalford Church that Bunyan pictured Christian and Faithful seized and brought before the Court of the fair, and poor Faithful sentenced by Lord Hategood 'to be led from the place where he was to the place from whence he came, and there to be put to the most cruel death that could be invented'. No doubt Bunyan's description of the trial of the two pilgrims at the fair is an exact picture of the methods of the Court of Pie-powder, or *Pied-puldreaux*, the tribunal which could be summoned at a moment's notice among the merchants of the fair. The Court of Dusty-Feet certainly worked with alarming despatch.

If Bunyan really drew his *Pilgrim's Progress* from his memories of the pilgrims and their fairs on the Way, he may have had other scenes in his mind which suggested other names. The Delectable Mountains may have been the blue line of the Sussex Downs, or the hills by Black Down and Hindhead. The Slough of Despond may have been the marshy pools of Shalford Common, or the ponds under the hill by Chilworth; and Doubting Castle, spelt Dowding Castle, is actually a name to be found on the Surrey map, south of Epsom Downs on Banstead Heath. But whether Bunyan ever saw it there is another matter.

Eric Parker

TWO STRANGE MEN

A pleasant and comfortable town is Guildford, much sought after as a place of residence by half-pay officers and ladies with a 'little in the funds',—a respectable, though dull community. 'We have five admirals, three generals, and I don't know how many colonels and captains waiting here now for houses.' Thus proudly spake a house agent there, and the slight air of contempt with which he referred to such commonplace persons as captains, served to show what an important place Guildford is. Such a town as this in the United States would have three

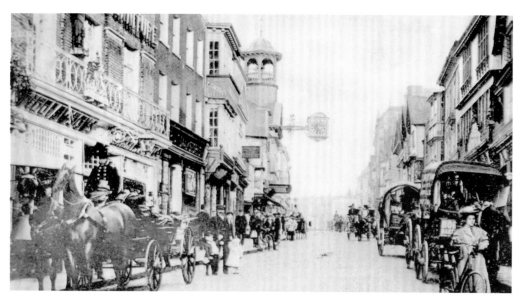

GUILDFORD HIGH STREET

or four newspapers published in it—here, I believe, there is but one. Perhaps the English provincial journalist is more fastidious than his American cousin, who sometimes finds a newspaper anything but a source of wealth. 'We are out of meat, money, and other things. We are out at elbow. We are out of patience.' This was the doleful complaint of an Arkansas editor, poor man, not long ago. Another aspiring intellect in Ohio boasted of having received one hundred and fifty new subscribers, but added, 'We want about two hundred more subscribers; we need a new pair of socks.' It was a more fortunate journalist who published the following triumphant leading article in a Tennessee paper; 'Halleluyer! we've got a new shirt.' Let us hope that the craft drive a more flourishing trade in this excellent town of Guildford.

While endeavouring to slake a raging thirst at the 'Angel' with sparkling hock and selzer water, two sunburnt and awkward-looking men entered the room. They sat down at the table, and one said to the other, 'I have ordered a thick soup, some salmon, some corned beef, and a claret cup.' And a very strange mixture it is too, thought I at three o'clock in the afternoon on a broiling hot day. Perhaps they are going to use the claret cup as a sauce for the salmon.

No, they did not do that, but they drank it copiously with the soup—a strong, dark-coloured soup, an old-fashioned commercial traveller's soup, in which the spoon will almost stand upright. It was passed round three times—an awful thing to witness on a hot day. Then these wonderful men began to exchange notes of foreign travel, and the following conversation took place—

'How did you like Bolong?'

'Pretty well, but what an ignorant set they are there! I went to the Station Hotel and asked what we could 'eve to eat. They said "Anything you like to order". So I said, "Soup and cutlets". They brought me about half as many cutlets as I could have eat myself, and there were three of us! "What will you like afterwards?" says the waiter. Says I, "A meat tea, and cook half a sheep for us." Here the two epicures nearly choked themselves under the combined influences of laughter and huge masses of food.

'Them French', said the other, 'don't know what good eatin' means. When I was theer, they told me I could have twenty-five courses, but I 'ud rather 'eve 'ed a bit of salmon than 'em all. (Putting half a pound or so in his mouth.) They know nothing about cookin' or eatin'.'

'The women are all ugly,' the salmon-devourer went on; 'and did you ever see such guys as the men?'

That is your opinion of the Frenchmen, thought I. I would now give a great deal to hear their opinion of you.

What were these men, I wondered—farmers? Farmers sitting here drinking claret cup, and gorging themselves with soup and salmon at three in the afternoon of a hot day? That was scarcely likely. So when I paid my bill, I

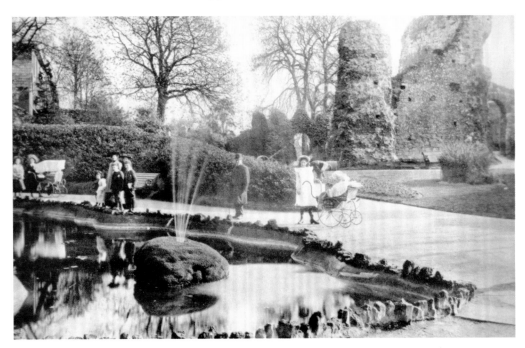

CASTLE GROUNDS, GUILDFORD

said to the host, 'Pray what are those two gentlemen in there—bagmen?'

'Auctioneers,' said he in a solemn whisper.

'Ah, good morning, Mr Michaux.'

'Good morning, sir.'

Whew! What a relief it is to get into the blessed fields and fresh air once more after sitting in the same room for an hour with some of our dear fellow-creatures.

Louis Jennings

THE CASTLE GROUNDS

The castle enceinte is now laid out as a pleasure ground, with all a public garden's advantages and disadvantages. Public taste demands 'bedding out', even though geraniums and calceolarias fit unhappily enough with masonry fourteen feet thick and Saxon earthworks. A bowling green is in its proper place; thorns and old rose-trees have a right to grow round ruined castles; wall-flowers belong to stones and mortar. But lobelias do not. Still, something even worse than bedding-out might have befallen the Castle grounds. Dr G.C. Williamson, in his valuable little book *Guildford in the Olden Time*, mentions that, when the grounds were bought for the Corporation in 1886, premiums were offered to various landscape gardeners for plans showing the best means of laying out the space. One of the plans which was rejected, although attractive in other ways, 'started its schedule of work with a suggestion that the ugly ruin in the centre of the grounds should be removed, and in lieu of it should be erected a light iron bandstand painted green, picked out with gold'. What, one wonders, were the other attractions of the 'landscape'?

Eric Parker

GUILDFORD MAID'S MONEY

January 25th 1900—The Custom of awarding 'Maid's Money' was observed on this date at Guildford. It arises out of a bequest made two hundred years ago when a sum of money was left to be invested in Government stock to produce the sum of £12.12s. as a reward for 'a maidservant who shall have lived for two years or upwards in one service in the old Borough of Guildford and who shall throw the Right number with two dice and cast lots

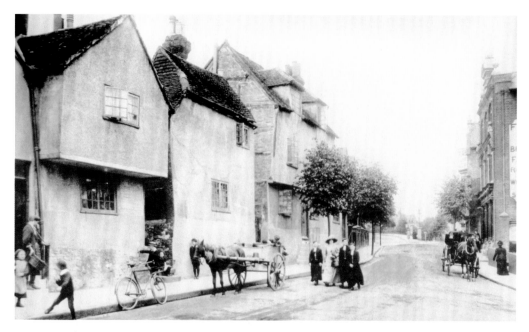

FARNHAM ROAD, GUILDFORD

with another maidservant'. The gift is always eagerly sought after, and every year the trustees have a large number of girls before them from whom they select two competitors. The donar's will provided that an unsuccessful competitor should be allowed to toss three times for the Money, providing she still resides in the Old Borough of Guildford and remains unmarried.

The Surrey County Magazine, 1902

THE DISGRUNTLED SHOPKEEPER

. . . The gorge is dotted all over with stunted shrubs and bushes, and in front, across the valley, are the dark woods of Wotton, with the old church peeping through the trees—as fair a scene as even the county of Surrey has to offer.

Towards this old church the walk should now be directed, down the hill towards the brick railroad bridge (not the wooden one), with the plantations of 'Wood Town' in front. The lover of nature will not be disposed to quarrel with this domain of the Evelyns, although a man whom I once met upon the railroad bridge was apparently not by any means satisfied with it.

'Fine view?' said he, in reply to a remark from me. 'Well, I don't call it so. I don't think it at all fine to look over miles of land which is kept up for a selfish purpose, and does no good to man or beast.'

Here, thought I, is one of those noisy demagogues who make out their country to be the worst on the face of the earth, without taking the precaution first to see how another would suit them.

'I suppose this man's land is his own,' said I.

'I don't know so much about that—very few of these large estates would bear closely looking into, in my opinion. They were got in queer ways, I can tell you that, and are chiefly held by men who look upon the labourer as they would on a dog. What right has any man to hold thousands of acres of land?'

'The same right that you have to that coat on your back—that is, supposing you have bought and paid for it.'

'Excuse me, sir: where do you come from?'

'Come from? Oh, all sorts of places. From America last, if it will do you any good to know'

'From America? Well, now, I believe the land is open to anybody there—to one as well as to another?'

'No doubt, if you have money enough to buy it. I never had any offered to me there for nothing.'

'And here, two-thirds of the whole country are in the hands of a few lords and squires—one man owns over

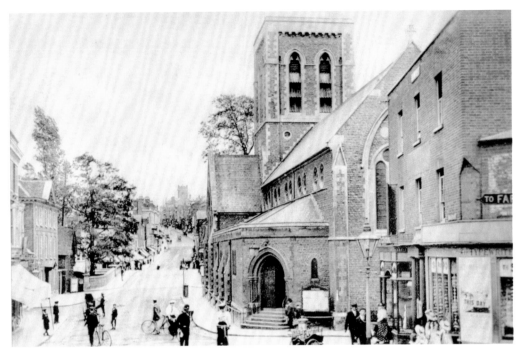

ST NICHOLAS, GUILDFORD

125,000 acres. Do you know that, sir?'

Yes, I had heard of that. My man seemed to have got the figures pretty pat.

'Now, do you call that right?'

'Pray, what are you?' I said.

'I keep a shop at Guildford.'

'Indeed? I wish I did. Shopkeeping is the only thing a man can make money at nowadays. Well, I daresay there are some people in Guildford who would like to have your shop, and wish much to get you out of it and themselves in. What would you say to them?'

'Say? Why, I should say they were quite welcome to my shop if they liked to pay for it. Why not? I am ready to sell it to you or to anybody else; and it ought to be the same with the land. What I say is that if you offer a fair price for the land you ought to have it, and that a few hundreds of men ought not to be allowed to monopolise all England. Why should not land be as free here as it is in America?'

'I have told you before that you cannot get it there without paying for it. And no man would be obliged to sell his land to you unless he liked.'

'But it is easy to get it there.'

I could only assure my friend that I had known a good many persons who had not found it at all an easy matter, although they had worked hard for it all their lives. A man may be as well off in a shop in the homely town of Guildford as in a log hut in the back-woods, if he only knew it.

Louis Jennings

SNIPPET

Proud Guildford, poor people
Three churches, no steeple.

Anon.

The above verse refers to St Nicholas, which was twice pulled down and rebuilt during the 19th century.

Walter Jerrold

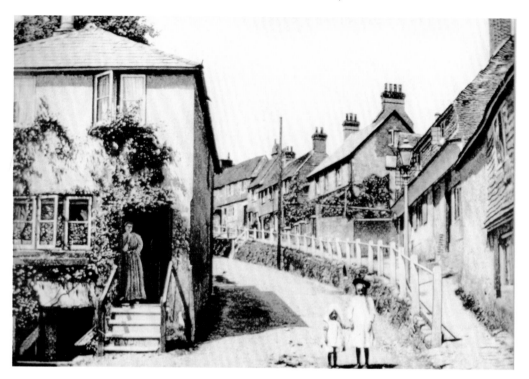

HASLEMERE

AN APPARITION

A remarkable story was told by the late Albert Smith with reference to Guildford Grammar School for which he says he could personally vouch. He states: 'About ten years ago, my brother was pupil at the Grammar School in that town. The boys had been sitting up all night in their bedroom, and in the early morning one of them—young K. of Godalming—cried out, "Why, I'll swear there is the likeness of our old huntsman on his grey horse going across the white-washed wall." The rest of the boys told him he was a fool and that all had better think about going to sleep. After breakfast was over, a servant came from K's family to say that their huntsman had been thrown from his horse, and killed early that morning while following the hounds: Albert Smith quaintly adds: 'leaving readers to explain this strange story, which may be relied upon I put my old books back upon their shelves and lay aside my pen.'

The Surrey County Magazine, c. 1900

LOCAL FOLKLORE

Surrey is not especially rich in folk-lore, but a certain number of superstitions linger here as elsewhere. A death in the family is duly announced to the bees; it is supposed that rain is wanted on St Swithun's Day to 'christen the apples', otherwise there will be no fruit.

Not so many years ago I knew an instance of an infant, who was badly ruptured, being passed through a holly tree as a charm. The process was the following, a slit was made in the tree, the parts of which were held asunder by two persons, while two women, one holding the child's head, and the other his feet, passed him stark naked several times backwards and forwards through the opening, and my informant added that the mark could be seen in the bark of the tree, and remarked 'I don't know that it was any good, but the old women at that time used to hold with it.' It is believed that a cake baked on Good Friday will keep any length of time, and not become mouldy, or 'mothery' as they express it. An old man told me that thirty years or more ago his wife had baked a cake on Good Friday, and hung it up by a string, that ten or twelve years afterwards it was quite good, and that he had eaten it in sop; he said further 'if you grate it and put it in gruel, it is a fine thing for the inside', meaning as a remedy for diarrhoea. This superstition is mentioned by Brand in his *Popular Antiquities* (Hazlitt's Edition, vol. i, p. 88).

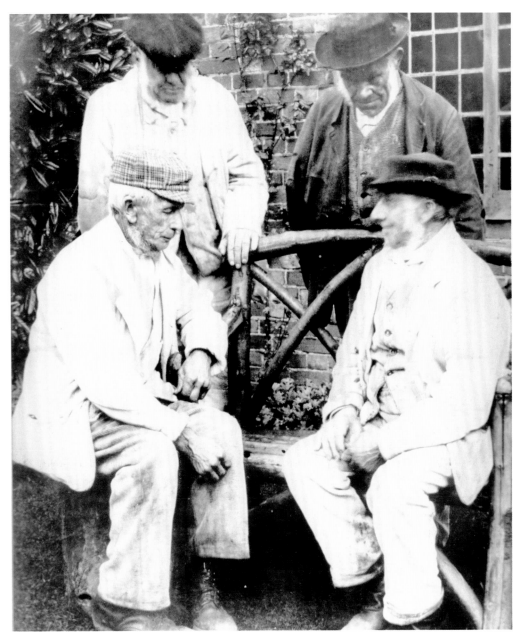

CONVERSATION PIECE

The like tradition as to its power to keep fresh, attaches to water caught on Ascension Day. The same man told me that 'if you ketch'd the rain water as it fell on Holy Thursday, and put it in a bottle and corked it, you might keep it as long as you would, and it would never go bad'.

I knew a case lately where, as a cure for whooping cough, a woman hollowed out a nut and put a spider in it, and hung it by a string round her child's neck, the idea being that when the spider dies the whooping cough disappears with it. The Rev. W. D. Parish mentions this as a cure for ague (*Sussex Dialect*, p. 64).

It is believed that the moss, or 'comb' (pronounced 'coom'), which collects on church bells is a cure for the shingles. I enquired one day the reason of my carter boy's absence, and the farm-man replied, 'He has got the shingles, and I have told his father to get the "comb" off the church bells and rub it into him; they say it's the best thing for it.'

Granville Leveson Gower

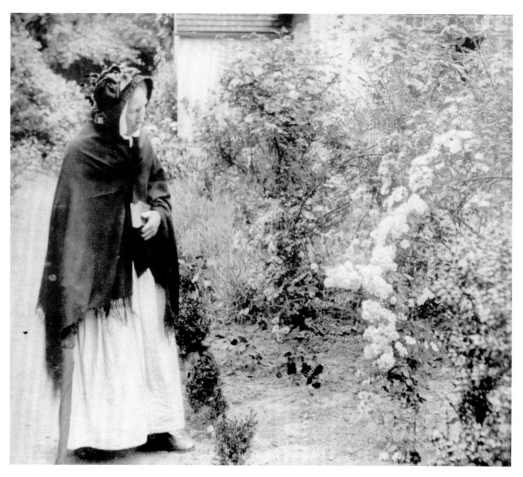

IN A COTTAGE GARDEN

A SURREY GARDEN

December 10th—There has been in this year's 'Guardian' a succession of monthly papers on a Surrey garden, written by Miss Jekyll of Munstead Wood, Godalming. I give her address, as she now sells her surplus plants, all more or less suited to light soils, to the management of which she has for many years past given special attention. These papers have much illuminating matter in them, and are called 'Notes from Garden and Woodland'. All the plants and flowers about which Miss Jekyll writes she actually grows on the top of her Surrey hill. Her garden is a most instructive one, and encouraging too. She has gone through the stage, so common to all ambitious and enthusiastic amateurs, of trying to grow everything, and of often wasting much precious room in growing inferior plants, or plants which, even though they may be worth growing in themselves, are yet not worth the care and feeding which a light soil necessitates if they are to be successful.

This, to me, rather delightful characteristic of amateurs in every art was severely condemned by Mr Ruskin in my youth, when he said that the amateur sketcher always attempted to draw the panorama of Rome on his thumb-nail, instead of humbly trying to reproduce what was at his own door. The practice is just as common in gardening as in music and painting.

Every plant that Miss Jekyll names is worth getting and growing in gardens that are of considerable size, and which more or less share her Surrey soil and climate. I trust that before long these articles will be republished in book form, for every word in them deserves attention and consideration.

Mrs C. W. Earle

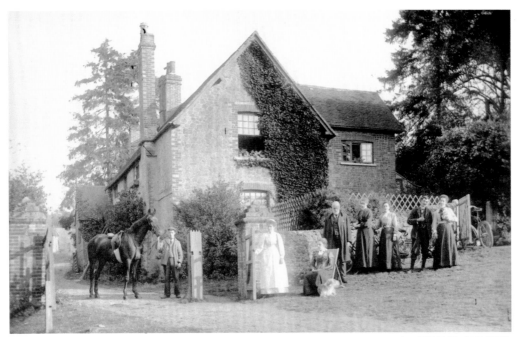

KEMPSLADE FARM, FRIDAY STREET, ABINGER

FRIDAY STREET

If the visitor is desirous of exploring this beautiful and little-travelled region, he will take a path which runs by the side of the house, but leaves it on the right hand. This affords an occasional glimpse of the gardens, and leads out to a quaint and most interesting spot called Friday Street, for which we may look in vain on the one-inch ordnance map. Yet it is a veritable street—a thoroughfare leading from one place to another, but so primitive in all its 'belongings' that in coming upon it one seems suddenly to have been put back a couple of hundred years in English history. It lies in a sort of ravine, with a large pond at one end of it, and beyond a few ancient and picturesque cottages. It has a totally 'untouched look', and, with its beautiful hills and trees, among which it lies hidden like a village over which some wizard has cast a spell, there is no place within the compass of a day's journey which will more delight the lover of those half-forgotten nooks and corners of 'Old England', now fast disappearing before the invincible march of time and improvement.

Louis Jennings

ABINGER

Abinger, on the high plateau, is a village delightfully feudal in aspect, equipped with stocks and whipping-post, which, I am told, were never used, because the men of Abinger always behaved themselves like good little children. There is the comfortable old inn, where the squire's portrait is hung up; the little school; the church, with the beautifully cultivated rectory garden, inseparable from the churchyard; the old covered-in stocks, the pound; and the village pond, in the water of which is reflected the blossom of overhanging wild cherries. Another place to loiter in and to spend lazy days.

F. E. Green

FAIRS

Chertsey still keeps up some fascinating customs. She has two quaintly named fairs 'Black Cherry Fair' on August 6 and 'Goose and Onion Fair' on September 26, when she presides over the selling of horses and poultry.

Eric Parker

THE FASTIDIOUS DONKEY

ROADSIDE SIGHTS

Donkeys are credited with feeding largely on thistles, those prickly roadside products. He may munch the tender tops of the plants now and then, but you do not catch the asinus harmonious, grass-organ, thistle-puke, or beesweet—all these names are given to that animal in our rural district—eating thistles when he can get better food. The donkey is very fastidious in many of his habits; in drinking he is particularly so. Shakespeare noted this, and one of his characters says—

> Would that the fountain of thy mind was clear,
> That I might water an ass at it.

No, not for donkeys do those thistles grow so rank and so luxuriously, but for the birds that flock to them for food when their seeds are ripe. It is one of the prettiest of my roadside sights, that of a flock of twenty or thirty goldfinches fluttering over the stems and heads of the thistles, and clinging to them in all manner of positions. Twenty or thirty I call a large flock—goldfinches are getting scarcer with us. Tit-mice—all the tits—feed more or less on thistle-seeds; in hard weather I have seen siskins and red-polls busily at work on thistles, for they were the only plants that rose above the surface of the snow.

 Blackbirds, thrushes, hedge-sparrows, willow-wrens, white-throats, and nightingales all nest and get their living by the roadsides. I have often listened to the nightingale singing not ten feet above my head, and have found his nest in the bank—and left it there—only a yard or two from the main road.

Denham Jordan

THE CARRIERS

Most of the fish for the London market was conveyed in special fish-vans from the various sea-coast places, such as Littlehampton, Bognor, Emsworth, and Havant. They were painted yellow and had four horses. But some of it, as well as supplies for other inland places, was carried in little carts drawn by dogs.

 The man would 'cock his legs up along the sharves', as an old friend describes it, and away they would go at a great rate. They not only went as fast as the coaches, but they gained time when the coach stopped to change horses, and so got the pick of the market. A dog-drawn cart used to bring fish from Littlehampton to Godalming,

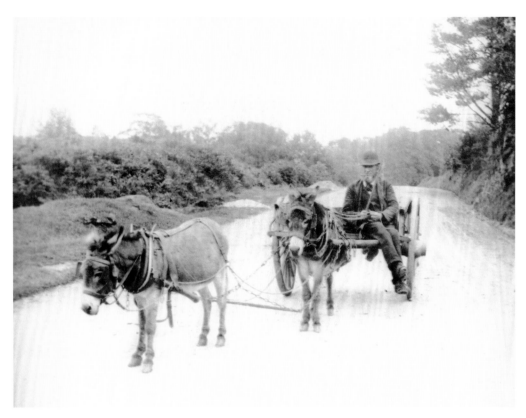

A CARRIER, WESTCOTT

where oysters were often to be bought for three a penny. A fish-cart man whose name was Jennivary, had his house of call in Rock Place.

Then there were the carrier's carts, also drawn by dogs. One of these I well remember, plying between Bramley and Guildford.

In these old days the great road waggons, drawn by six horses, went their long-distance journeys, carrying cattle and sheep to the London market, and bringing back loads of groceries and whatever was wanted. One of these went twice a week between Chichester and London. Besides these there were numbers of the carriers' one-horse vans such as still go short journeys between villages and country towns.

Now the carriers carry note-books, but the older men, who could neither read nor write, could *remember*, and would fill their vans with their many commissions without forgetting anything or making a mistake.

Gertrude Jekyll

THE MYSTERY OF HYDON BALL

Hydon Ball, or Highdown Ball as it is sometimes written, the highest point of a range of hills to the south of Godalming, overlooking the wealds of Surrey and Sussex, has a curious old rhyme associated with it, to the following effect:—

> On Hydon's top there is a cup,
> And in that cup there is a drop,
> Take up the cup and drink the drop,
> And place the cup on Hydon's top.

The exact meaning of the mystic ceremony here alluded to is perhaps for ever lost, but it seems not improbable that it had some reference to a religious rite, and probably it is of great antiquity.

Granville Leveson Gower

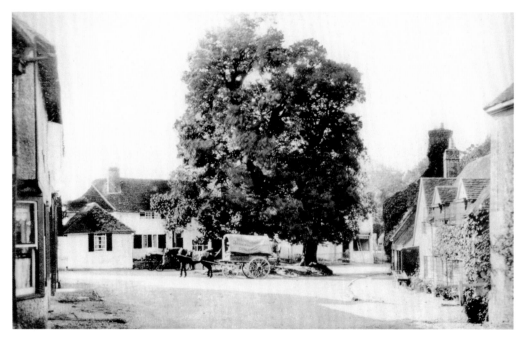

THE SQUARE, SHERE

AROUND SHERE

A path along the banks of the Tillingbourne, a clear trout-stream which runs through the park at Albury, brings us to Shere, one of the most charming villages in all this lovely neighbourhood. For many years now Shere has been a favourite resort of artistic and-literary men, who find endless delight in the quiet beauty of the surrounding country. Subjects for pen and pencil abound in all directions; quaint old timbered houses, picturesque water-mills and barns, deep ferny lanes shaded by over-hanging trees, and exquisite glimpses of heather-clad downs meet us at every turn. After passing Gomshall, the station for Shere on the South-Eastern Railway, we can regain the open country by a lane which turns off the Abinger Arms, and follow some of the rough paths which lead along the downs, for the sake of the beautiful prospect they command over Leith Hill and Holmbury. Fair as the scene is, travellers are seldom seen in these hilly regions; and so complete is the stillness, so pure the mountain air, that we might almost fancy ourselves in the heart of the Highlands, instead of thirty miles from town. Here it was, in the midst of the wild and lovely scenery of these Surrey Hills, that a sudden end closed the life of a great prelate of our own days, Samuel Wilberforce, Bishop of Winchester. A granite cross at Evershed's Rough, just below Sir Thomas Farmer's house at Abinger Hall, now marks the exact spot where his horse stumbled and fell as he rode down the hill towards Holmbury on that summer afternoon.

Julia Cartwright

THE SILENT POOL

To gain the Silent Pool, if you are in Albury, walk eastwards right through the village and turn to the left over the Tillingbourne. Then to the left again, and you will spy a cottage, the gate of which bears the legend 'Key of the Pool kept here'. How should a pool have a key? It turns out to be two keys, one of a padlock shutting an iron gate leading to a grove of box trees; you shut the padlock and find that you have left all who come after you—and on Saturdays at least they are many—to climb the fence. The Silent Pool, when I saw it first, a little disappointed me. I ought to have known that it would, because everybody could tell me where it was, even quite unintelligent people walking about the road two miles away. I think I hoped the pool would be, not only solitary and sequestered, but entirely deserted by human beings; a pool on which you came suddenly, lying hidden in the heart of chalky dells, dark green with box trees; it was to be as deep as a well, and cold with the coldness of a spring; smelling, too, of

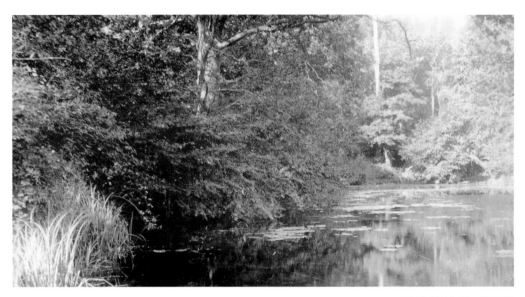

SILENT POOL, SHERE

bitter wet box and sun-warmed chalk. It was to be a pool at the side of which the stranger should seat himself, and discover the air of the place so quiet and enchanted that he could hear no sound of birds or beasts or men; only, perhaps, the melodious drip of the rain-heavy boughs into the clear peacock-green depths of water. And, in fact, the disappointment is that this is precisely what the Silent Pool might be. It is what it used to be, I think; but so many people have heard of it and have come on bicycles and in carriages and motor-cars to see it, that the leaf-strewn paths are trampled into mud round it; and it cannot be called silent, for you will not escape hearing other people, who have quite as much right as you to be there, talk about it and tramp round its margin. Then, too, for the convenience of visitors, there has been built on the edge of the pool a thatched arbour of wood, into which you admit yourself with a very large key, only to be deafened on the spot by ten thousand cockney names scrawled on the white walls round you. Those who have gibbeted themselves on the walls have also thrown the newspapers that held their lunch into the water, and bottles with the paper—a most unhappy spectacle. Had I the right to touch the place, the arbour would be packed up offhand for Rosherville. Only in one particular has the arbour any claim on the wayfarer's gratitude. It enables him to watch the large trout which swim in the clear deep water under him as closely as if they were behind the glass of an aquarium. Trout which leap out of the water every two minutes in a spring afternoon, and yet which are tame enough to come and be fed under the rail of a wooden arbour by trooping visitors are a sight for idle fishermen to see. I have fed them with worms, but I suspect them to be better used to sandwiches.

The road runs eastward a mile from Sherborne ponds to Shere. Who first named the Shire-bourne pond the Silent Pool? The old name is the best, and the water of the pond ought to be added to the beauties of Shere. If Shere is to be counted the prettiest Surrey village of all, I think it is the Tillingbourne which decides the choice.

Eric Parker

EPITAPH

At Ockham there is the following inscription to the memory of a man who met his death by falling from a tree:

> The Lord saw good I was topping off wood
> And down fell from a tree;
> I met a check, I broke my neck
> and so death lopped off me.

The Surrey County Magazine, 1899

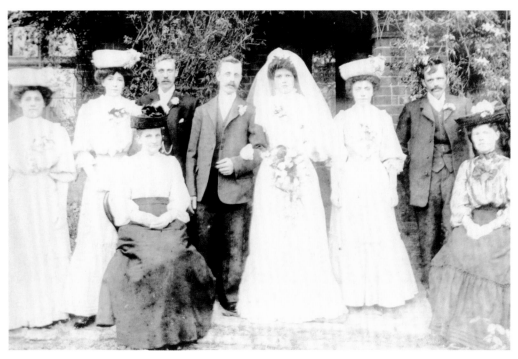

WEDDING PARTY

MARRIAGE

Aug. 7.—Bertram Reginald Warren, of Upton Park, Slough, and Marjorie Rachel Mary Bray, of the Manor House, Shere.

The principal topic this last month has been, of course, the Wedding! The 7th was a lovely day, all that we had hoped for, and everything passed off as happily as possible, and all expectations were fully realised. All classes combined to make the village look as festive as possible for the occasion, and with great success. The evergreen arches over the bridge and Church gateway, the decorated archway over the Upper street, the long lines of Venetian masts, with connecting strings of bright flags and streamers, the many private decorations, connecting house with house, or adorning gateways with gay device and apt mottoes, and the firemen's gallant turn-out, all combined to make a right royal display. The mottoes across the main street formed the following verse:—

> Hail, happy day, that joins in one
> Fond heart to heart for evermore!
> In fervent prayer we all unite:—
> May God on Bride and Bridegroom pour,
> Through long sweet years of wedded love,
> Rich blessings from His bounteous store!

A prayer that was indeed heartfelt throughout the community. The decoration of the Church itself was most beautifully carried out to harmonize with the costumes of the bridal party, and the marriage service was very bright and hearty. After the wedding by the kind invitation of Mrs Bray, almost every woman in Shere, Gomshall, and Peaslake, was entertained at the Manor House, and witnessed the departure of the happy pair, and inspected the wedding presents. A display of fireworks ended a day that will long be remembered here with the most sincere happiness and goodwill. Among the many presents none gave more satisfaction than the silver salt-cellars, presented by the village tradesmen, and the handsome silver salver, that formed the spontaneous offering of the women of the parish. If good wishes can add anything to the happiness of this very happy pair, they will *indeed* be happy!

Shere Parish Magazine, September 1915

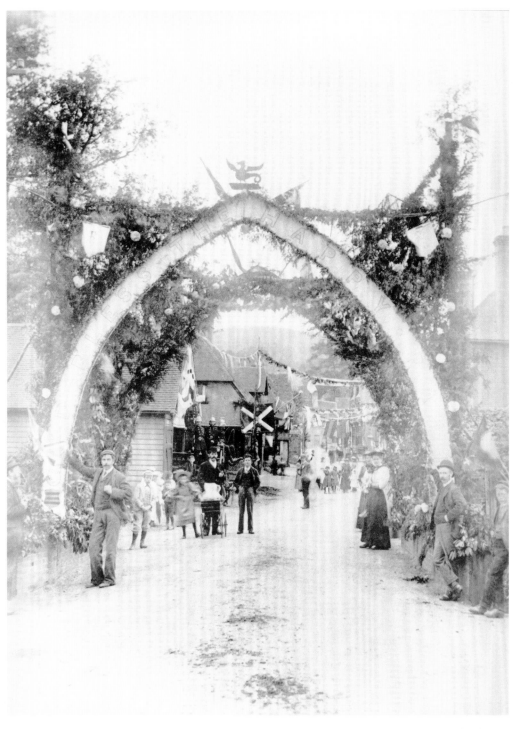

BRIDAL ARCH

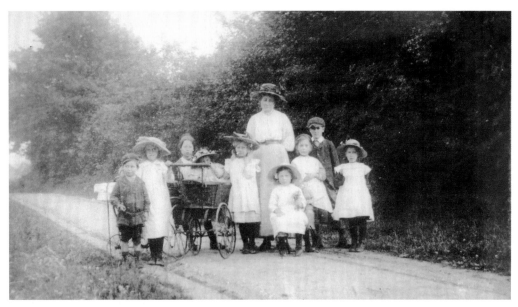

WESTCOTT CHILDREN

THE UPBRINGING OF CHILDREN

I feel sure you all, as my nieces, care enough for my views on most things to wish for a few remarks on the great question of how to bring up boys and girls. The opinion of anybody who has thought at all and who has lived a long life is worth having as the personal experience of one individual. Age is to life what distance is to landscape, it makes all things assume fairer proportions and embrace a larger horizon. We see more plainly the good and the bad in all systems, any convictions we may still have we hold conditionally, and we lose the confidence with which we stepped out when we knew less and felt more.

'RON'

I had better begin first with the boys, and speak of the girls later on, which is certainly dealing with the matter in the old, conventional way.

It is a well-known fact that more boys are born into the world than girls, but they are more difficult to rear, which accounts for the greater preponderance of women in the end. I suppose I ought to have more to say about boys than girls, for, as you know, I have had only boys of my own. My mother used to say it was a merciful interposition of Providence that I had no girls, as I was totally unfit to bring them up. Naturally I do not agree with this, and should have liked immensely to have had three girls as well as three boys.

The health question from the very beginning is one of the greatest importance. In the case of boys, at any rate, it cannot come naturally to any young mother. Her knowledge and intelligence, however, should at least be sufficient to let her know when things are not going right. As a rule, children grow up as 'Topsy' did; "Specs I growed'. But every now and then terrible things happen which, with a little sense

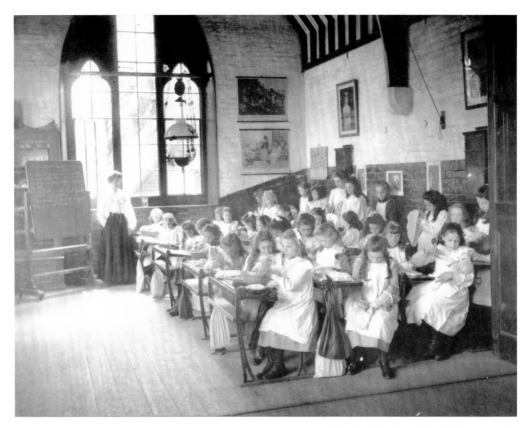

'WASHING AND DRESSING A BABY'

and knowledge of when to call in a specialist, are quite preventable. I pity the parent who has to say: 'Alas! I knew too late.'

One of the great difficulties in the emancipating of the children of the well-to-do—by which I mean helping them to learn independence, and to take care of themselves in early childhood—is the nervousness of mothers and nurses. If parents would only consider how sharp are the children of the London poor in looking after themselves, I think they would gain courage, and their children would profit. I know a child, the youngest of a family, a fine, plucky little fellow, whose whole nature was altered by being put out of frocks into knickerbockers and his hair cut short when very young. One day this child was taken by his father, at the age of four and a half, to the City, and sent back alone on the top of a 'bus that set him down at the end of the street in which he lived. He had been given sixpence to pay his fare, and, arriving at home safely, he proudly and triumphantly handed the change to his mother. This same child, at twelve years old, after leaving his private school, and before going to a public school, was sent to Paris to learn French. With a guide-book in one pocket and a map in the other, he found his way about alone all over the town. To my mind, precocity that comes from development of character and independence, or from the stimulus of ambition, is as desirable as that resulting from over-excitement or overbookwork is the contrary.

As soon as children are no longer babies, it is very unwise to leave them much with servants. Little boys have no natural employments at home, especially in towns, when once they go to school. I should recommend parents who live in London to give up dining out during the winter holidays. It is only for four weeks, and the evenings at home with parents out are certainly dull for boys; this applies doubly where there are no sisters. I used to think the perfect education for boys was the foreign way, to live at home and attend a day school: but the universal condemnation of this system by young Englishmen has shaken me, and certainly we have hardly any machinery prepared for carrying it out. The public school system, therefore seems to be the only one here. At any rate, boys are brought up at school in the mythologies of their time and country, as Huxley used to recommend: and on the

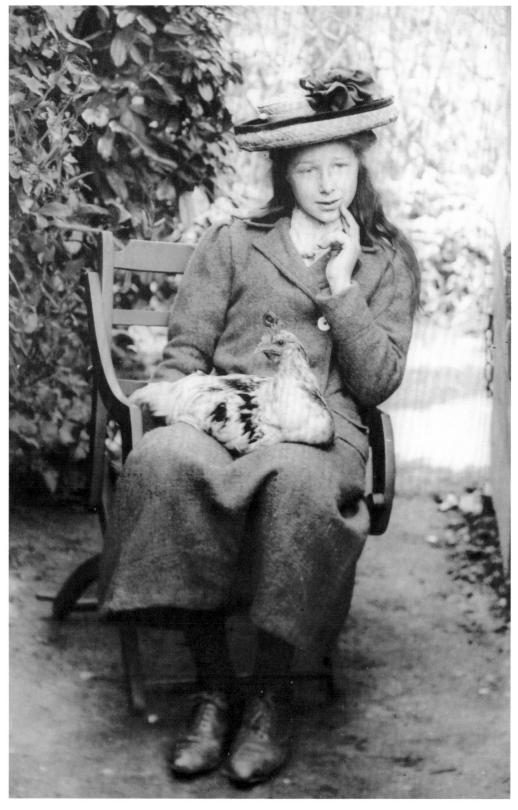

DEEP IN THOUGHT

PLAYTIME

whole that seems to answer best. The thing most to be avoided, it appears to me as I look back on life, is bringing up children on any sort of fad, however genuine the conviction of the parents that they are right and other people wrong. There is no mistaking the bitterness with which young men talk if they have been brought up in any way that alienates them from their generation. This applies equally to great and little things—from the training of the strict Anglican clergyman, or in the Agnostic's morality, to affectations in dress and peculiarities of diet.

Mrs C. W. Earle

IN THE OLD DAYS

The children were better disciplined and therefore better mannered in these old, hard-working days. Boys in a labourer's family, when a meal was ready, having made themselves clean, stood in a row while grace was said, and did not sit down till they were told.

'I mind when we always ate off wooden trenchers, not crockern plates,' said one of my old friends. 'When we used to have a meat pudding, it was boiled in a pudden cloth, not in a basin as now. There was meat and vegetables and all inside. Each child got a piece of the pudding (the paste), some of the vegetables and some gravy. The meat was kept for next day. It was just the same in the farms, the children didn't dare sit down till they was told.'

Children had not so much playtime in the older days, but girls had more than boys. When several were together they formed a ring and played by various rules. The simplest form of game I remember was played by a ring of children sitting on the grass. One stood out in the middle and gave the signal to the others, who all imitated what she did. The leader would stand up and raise her arms, and wave them up and down three times. Then she would sit down and rock her body three times to and fro. After a few such antics, the last of them in a sitting position, she would jump up and twirl round and sit down again quickly. This was really pretty, and was considered the crowning moment and great joke of the whole game, and was often repeated during its progress.

Gertrude Jekyll

FOREST GREEN

OLD BELIEFS

We had comical ideas about health, or perhaps it would be better to say No ideas at all. I have told how I was taken to see a man lying in a stupor of small-pox. Of course modern precautions against disease were unknown. People often could be seen with respirators. Tubercular consumption was called 'a Decline'. If measles broke out in a family, it was more common sense to let all the children sleep in the same bed together, for there was no avoiding this trouble, and to have it all over and done with at once was a saving of the mother's time in the end. The same reasoning applied to scarlatina. As for whooping cough, it could not be got rid of until May, but then it was sure to go. I never heard of chicken-pox, or of German measles; quite possibly one or other of these ailments was what we called simply 'a rash', which would disappear after a day or two if left alone. Although in the silly game, Punch was said to have died 'in a fit', and it was asked 'What sort of a fit?' no discrimination was ever really attempted. Only 'a fit' was a nasty dangerous thing. If you dropped dead 'in a fit' you would be 'brought home on a shutter', as there was no ambulance, but every shop had shutters. Dangerous it was, too, to cut your hand between finger and thumb, that being a sure way to get lock jaw. If, when a tooth came out, you neglected to show it to your father or mother, it was only too likely to be replaced by a dog-tooth. To have an eye-tooth pulled out might be very bad for the eyes. A good way to get rid of a loose tooth was to tie it with cotton to the window-fastening; then get somebody to go outside and dash a bucket of water at the window. Involuntarily you recoiled; and when you recovered, you found that the tooth was hanging on the cotton, clear of your gum. But who troubled about teeth in those days? To go to a dentist was almost unheard of. There were no anaesthetics—you might as well suffer the decay of teeth as the certain agonies of dentistry, for which moreover the professional charges were quite beyond the reach of the humbler shopkeepers like my father and mother. To a large extent this applied to the medical profession all round. You took risks, for it cost too much to go to a doctor. You took powders too! True, my father set his face against the practice. But one had grandmothers also; and there were convenient doses to be got at a grocer's—senna, rhubarb, camomile, Stedman's powders, and a loathsome brown powder we called 'Grandmother's powder' which we hated—fortunately for it contained some form of mercury.

 A certain danger attended grimacing—you might 'get fixed so' by a malicious Fate, and it would be awful! Distressing indeed were some of the prospects one faced. I once pushed a finger through the hole in the arm of a

BRIDGE COTTAGE

baby chair, and for an agonised half-minute faced the expectation of wearing that chair for the rest of my life. Rings (what rings can they have been-,) too often got alarmingly fixed below my finger joint, and there was disquieting talk of soaping the finger to get the ring off. Yes, that was disquieting. What if the soap should tail% It was dangerous to chew string or to bite cotton instead of taking scissors to it, for, if swallowed, string or cotton might wind round your heart and kill you. Not dangerous was it but truly painful to swallow a large sweet too soon. As it lay 111eltlng, the dull ache across your chest was aggravated by the thought how nice the sweet would have been between the teeth. For in those days one's teeth were strong enough to crack a nut; and it was sheer delight to scrunch up a sweet. You could bite the end off a twisted sugar-stick or a plait of barley-sugar; there was only a little risk of getting your jaws fixed uncomfortably in a piece of liquorice; but the really tiresome thing was one of the large square acid-drops. The smaller round sort, which got damp and clogged together in their little paper bags, were as safe to suck as they were nice; so were their sister peardrops and raspberry-drops. Bull's eyes—those magically streaked peppermint bull's eyes—never misbehaved; no lump of sugar-candy got stuck in one's gullet; cakes of 'hard-bake', thick with white almonds, were at worst no worse than 'stick jaw'; but the large square acid-drops only too often slid down before one knew; and then their square corners hurt like anything. By the way, at Farnham Fair we used to get, in a little twist of paper (do you know how to twist up paper into a small bag?) a handful of those tiny sweets called 'Hundreds and Thousands', that melted on the tongue like dust of sugar.

We had a wholesome dread of all berries from the hedge. Haws indeed I ate (they had a foul name), though despising, even in those unsophisticated years, the thin layer of fruit round the comparatively immense stone; but I chanced no other wild fruit, save blackberries. For a certain name frightened me, Deadly Nightshade. I did not actually know the Deadly Nightshade. I am not sure even now that I have ever seen it; but the name was awful enough. It scared me not only from the privet and barberry and other black and blue fruits which might be 'deadly' for all I knew; it also joined forces with another scare-word—'poison'—to make me shy of scarlet haws, vermilion 'Lords and Ladies', and other beautiful things, some of which doubtless may not have been good to eat, but all of which were 'poison' in my belief. Apparently I feared death; it is not clear why. Worms that had been mangled under the spade were thought to die and escape their agony, but not before night.

George Sturt

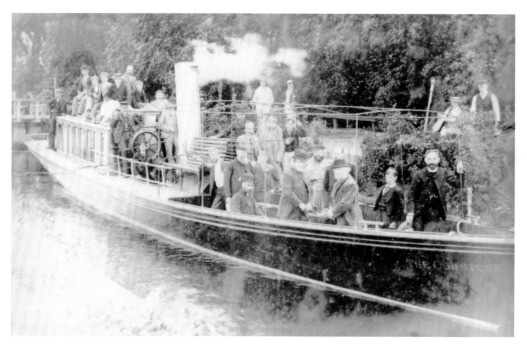

CHURCH CHOIR OUTING

THE CHOIR TRIP

Through the kindness of the Vicar, the gentlemen of the Parish Choir, and several others closely connected with the Church and the Schools, had a most delightful trip on Tuesday, July 18th. Starting at 7.20 a.m. for Windsor, the party, on arriving at that historic town, went on board the steam launch 'Countess', which was headed up stream, after a short delay. On arriving at Boveney Lock the launch and her passengers were photographed by an adventurous local artist (the proofs have since come to hand, and are very good). Passing through perhaps the prettiest scenery, of its kind, in England, the party safely reached Henley before 3 p.m. After about half-an-hour spent there, the return journey was commenced. The weather had been perfect all day, but a drizzling rain commenced some few miles before Windsor was reached; not sufficient, however, to damp the pleasure of the day. All who were privileged to take part in this truly delightful expedition, will mark the day in red letters in the calendar of their memory, notwithstanding the little rain at the end, and the breakdown of the engine of the train in which they were returning from Clapham, a little this side of Epsom, which compelled them either to wait an hour-and-a-half, or walk home.

Leatherhead Parish Magazine, August 1893

HIGHBURY

There have been many attempts made by Miss Austen's readers to identify Highbury, 'the large and populous village, almost amounting to a town' of *Emma*, with some Surrey town or village. There is a school of serious students who place it at Esher; another band of enthusiasts support Dorking. Mr E.V Lucas, in his engaging introduction to a new edition of the novel, has another suggestion. He recommends the theory that Highbury was Leatherhead, which satisfies most of the conditions of the book. It is, as he says, rightly placed as regards London, Kingston and Box Hill; though seven miles, which was the drive from Hartfield to Box Hill, is surely rather a generous estimate of the actual distance. But Leatherhead certainly has a river and a 'Randalls', and Mr Lucas has been told that it has an 'Abbey Farm'. That may be a mere coincidence; but, if so, it is the more striking when one turns to the parish registers, and finds in them the uncommon name of Knightley. Mr Knightley, in 1761, raised the pulpit of the church, and erected a new reading desk and seat for the clerk, and it was 'hereby

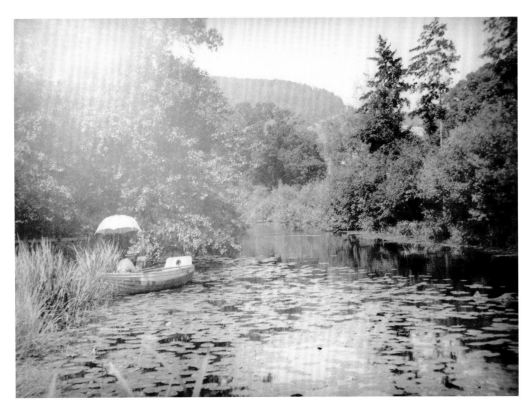

RIVER MOLE, DORKING

ordered that the thanks of this vestry be paid in the most respectful manner to Mr Knightley for this fresh mark of his regard'. Surely that is precisely what would have been the attitude of Mr Elton's parishioners to Emma's husband. If Miss Austen read the parish literature, she may also have set eyes on a poem entitled, 'Norbury Park', which was written by a minor bard of the neighbourhood named Woodhouse. But that is insisting too much; though, to be sure from the quality of his verse, Mr Woodhouse, author of 'Norbury Park', may well be imagined to have had, like Emma's father, a nice taste in gruel.

Eric Parker

HISTORIC DORKING

The Town of Dorking lies in the break here made in the chalk hills by the passage of the River Mole: Milton's 'sullen Mole that windeth underground', or, as Spenser sings in his 'Faerie Queen',—

> Mole, that like a mousling mole doth make
> His way still underground, till Thames he overtake.

The Mole owes its fame to the fact that it is so seldom seen, and several of the swallows or gullies into which it disappears at intervals along its chalky bed are at Burford, close to Dorking. The ponds which supplied the perch for that *water-sousie* which Dutch merchants came to eat at Dorking, are still to be seen in the fields under Redhill, and near them many an old timbered house and mill-wheel well worth painting. Today Dorking is a quiet, sleepy little place, but its situation on the Stane Street, the great Roman road from Chichester to London, formerly made it a centre of considerable importance, and the size and excellence of the old-fashioned inns still bear witness to its departed grandeur. Pilgrims to Canterbury crossed the Mole at Burford, about half a mile from the town, where the remains of an ancient shrine known as the Pilgrim's Chapel are still shown in Westhumble Lane. Here it bears the name of Paternoster Lane, and the fields on either side are still called Pray Meadows. From this point the path runs along under Boxhill, the steep down that rises abruptly on the eastern side of

BOX HILL

Dorking, and takes it name from the box-trees which here spring up so plentifully in the smooth green turf above the chalk. Boxhill is, we all know, one of the chief attractions which Dorking offers to Londoners. The other is to be found in the fine parks of Deepdene and Betchworth, immediately adjoining the town.

Julia Cartwright

DICKENS' DORKING

Most readers of *Pickwick* will remember that when poor old Weller made that fatal blunder with the widow it was in the ancient town of Dorking, at the 'Marquis of Granby', that he settled down. There the memorable scenes took place between the 'shepherd', Sam Weller, the mother-in-law, and 'Old Nobs'. There are inns without number in Dorking, but there is no 'Marquis of Granby' among them. It is generally believed that the 'Old King's Head' was the tavern which Dickens had in mind when he drew the picture of the comfortable old-fashioned bar in the twenty-seventh chapter of *Pickwick*. It stood on the site of the present post-office, and some portions of the building still remain at the back. There was formerly a coachman named Weller in Dorking, who drove the coach, and afterwards the omnibus to the station, for many years. This establishes a sufficiently strong relationship between Dorking and *Pickwick*, and a more recent writer, Colonel Chesney, has made the name of the town familiar to thousands who have never seen it. I have an American friend who, relying upon the hazy ideas of history which fill the heads of the common run of people, is in the habit of saying, 'Of course you remember the battle of Dorking? Well, this was the very place where it was fought!' It is astonishing how many persons there are who do not feel themselves in a position to throw any doubt on this sanguinary engagement.

Louis Jennings

THE ROAD TO EFFINGHAM

Opposite the black shed a path may be seen winding round a tree, and running diagonally across two fields. That is now our road. When you come to the second field you will be rewarded with a fine and entirely new view of Box Hill. Ranmore Common, uneven and covered with trees and ferns, lies to the right; to the left is the ridge with Polesden adorning its side, and between is a deep and well-wooded gorge; while beyond all is Box Hill, with its scarred face turned towards the spectator. The whole scene is full of wild and rugged beauty. And within ten

VIEW FROM RANMORE

minutes' walk there is a total change—a change as great as if you had been transported a hundred miles away on the magic carpet of the Arabian wizard. The path which we have been following comes out upon the main road to Horsley, near two cottages known as 'High Barn', and there the wide and open country lies extended before us, stretching far away into Berkshire to the front and left, and to the right over Epsom and Banstead Downs. In the foreground are the villages of Effingham and Bookham. The hills have entirely disappeared, and the whole country has changed suddenly into smiling fields, dotted with old church towers.

Louis Jennings

ON RANMORE COMMON

The best way is to start from Dorking, and to make for Ranmore Common by the narrow path, already described, just beyond the lodge gates. Having come out opposite to the post-office, the people about—if you meet with any—will tell you that it is a 'straight line' to Guildford, but before you have reached your journey's end you will be of a different opinion. I started off betimes on a fine morning towards the end of July to do this walk, in the hope that the day would turn out cool and pleasant, since there had been a stiff north wind blowing all night. But long before ten the sun burst out in a great hurry, and made up for a little lost time that day by producing a temperature which would have done no discredit to Calcutta. By that time, however, I was a couple of miles on the journey; and, as I hate to turn back when once I have started off, I determined to push on and take my roasting. And a pretty thorough roasting it proved to be; most people may remember that the summer of 1876 was rather hot, and this happened to be one of the very hottest days of that summer. More than once in the course of that tramp I would have given a good price for a bottle of soda-water, but between Dorking and Guildford there is nothing whatever to be had except fresh air and plenty of trees and one cannot drink them.

The road over Ranmore Common must be followed as far as the point described in the walk to 'Pickett's Hole', and then the next turning to the left must be taken—a broad green lane, on the main road to East Horsley, a little below the gate which shuts off the common. The green road cannot well be missed, for at this part it is nearly as wide as Fleet Street. 'Keep on that and you can't go wrong,' said a man who was tying up fagots on the common. But, like most other right roads in life, it is far easier to get off it than to keep on it. Sometimes one strays away without knowing it—sometimes you stand looking at two or three paths exactly alike, and wondering which is the right one? For although the 'course' is west, yet sharp bends have sometimes to be made to the north, and any man who tries to find his way without a compass will most certainly go wildly wrong.

Louis Jennings

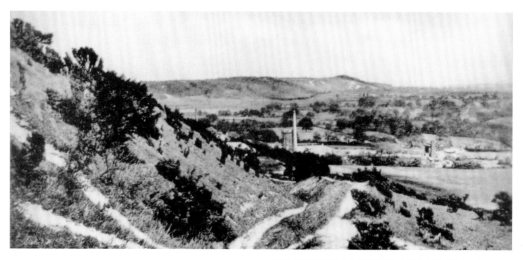

BETCHWORTH'S HILLS AND PILGRIMS' WAY

LIME PITS

After one turns the corner of Box Hill and enters this new division of the road is a great lime pit, which is called Betchworth Pit, and next to it a similar work, not quite as large, but huge enough to startle any one that comes upon it suddenly over the edge of the Downs. Between them they make up the chief landmark of the county.

We had already come across the first working of this kind shortly after we had recovered the Old Road beyond Gomshall, but that and the whole succeeding chain of pits were now disused, grown over with evergreens and damp enormous beeches. We had found a more modern excavation of the sort at the end of Denbies Park; it was called the Dorking Lime Works. Here, however, in these enormous pits, we came to something different and new. I looked up at their immensity and considered how often I had seen them through the haze; two patches of white shining over the Weald to where I might be lying on the crest of my own Downs, thirty miles away.

It is the oldest, perhaps, of the industries of England. Necessary for building, an excellent porous stratum in the laying of roads, the best of top-dressings for the stiff lands that lie just beneath in the valley, chalk and the lime burnt from it were among the first of our necessities.

Its value must have come even before stone building or made roads or the plough; it furnished the flints which were the first tools and weapons; it ran very near by the healthy green-sand where our earliest ancestors built their huts all along the edges of their hunting-ground, the Weald, on ridges now mostly deserted, and dark for the last three hundred years with pines.

The chalk, which I have spoken of coldly when I discussed the preservation of the Old Road, should somewhere be warmly hymned and praised by every man who belongs to south England, for it is the meaning of that good land. The sand is deserted since men learnt to plough; the Weald, though so much of its forest has fallen, is still nothing but the Weald—clay, and here and there the accursed new towns spreading like any other evil slime. But the chalk is our landscape and our proper habitation. The chalk gave us our first refuge in war by permitting those vast encampments on the summits. The chalk filtered our drink for us and built up our strong bones; it was the height from the slopes of which our villages, standing in a clear air, could watch the sea or the plain; we carved it—when it was hard enough; it holds our first ornaments; our clear streams run over it; the shapes and curves it takes and the kind of close rough grass it bears (an especial grass for sheep), are the cloak of our counties; its lonely breadths delight us when the white clouds and the flocks move over them together; where the waves break it into cliffs, they are the characteristic of our shores, and through its thin coat of whitish mould go the thirsty roots of our three trees—the beech, the holly, and the yew. For the clay and the sand might be deserted or flooded and the South Country would still remain, but if the Chalk Hills were taken away we might as well be the Midlands.

These pits which uncover the chalk bare for us show us our principal treasure and the core of our lives, and show it us in grand façades, steep down, taking the place of crags and bringing into our rounded land something

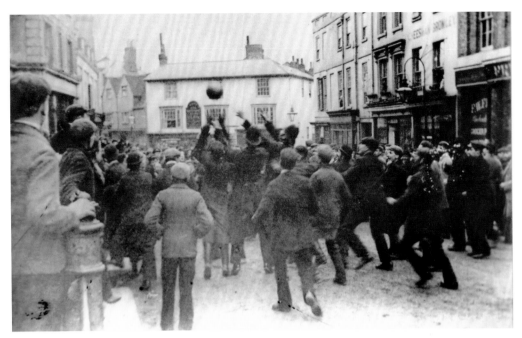

LAST SHROVE TUESDAY FOOTBALL MATCH, DORKING

of the stern and the abrupt. Every one brought up among the chalk pits remembers them more vividly than any other thing about his home, and when he returns from some exile he catches the feeling of his boyhood as he sees them far off upon the hills.

Therefore I would make it a test for every man who boasted of the South Country, Surrey men (if there are any left), and Hampshire men, and men of Kent (for they must be counted in): I would make it a test to distinguish whether they were just rich nobodies playing the native or true men to see if they could remember the pits. For my part I could draw you every one in my country-side even now.

Hillaire Belloc

CUSTOMS

The tolling of the 'pancake bell' was kept up at Dorking every Shrove Tuesday until a recent period, and as late as the year 1862, if not more recently, the day was observed by many ancient customs. First the streets were perambulated by the football retinue, composed of grotesquely-dressed persons, to the sounds of music, and the afternoon was devoted to the kicking of the ball up and down the chief streets. The play was often rough, and sometimes, as the afternoon advanced, even dangerous to the limbs of the competitors.

Palm Sunday was formerly an important day at Crowhurst. From time immemorial a fair or wake was held on that day in the churchyard, liquors were sold, and excesses frequently committed.

Another curious custom, and one which bears the mark of extreme antiquity, was the annual pilgrimage of all youths, maidens, old folks, and children, to St Martha's Hill on Good Friday. Music and dancing were the chief amusements in which. the pilgrims indulged, and the meaning of the festival is involved in great obscurity, but it is not improbable that it is some kind of survival of an early religious ceremony. It clearly has no reference to the solemn event celebrated upon Good Friday by Christians.

Michaelmas Eve, or the Sunday evening which preceded it, was called at Kingston-on-Thames, 'Crack-Nut Sunday', from the curious custom which prevailed among the congregation of cracking nuts during the service in the church. It has been thought probable that this custom may have originated from the usual civic feast attending the choosing of the bailiff and other members of the corporate body on Michaelmas Day.

George Clinch

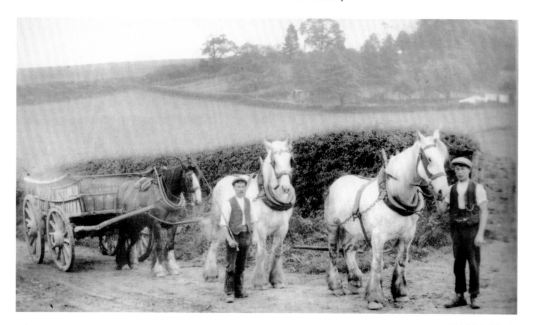

FARM CART

THE WAGGON

I was really pained at the sight of an old farm-waggon being trundled along with a load of bricks towards what had been a quiet country place on the Surrey and Hampshire border. It was bad enough for bricks to be going there at all—to desecrate some ancient heath or woodland or field. Too plainly Old England was passing away; villas were coming, the day of farm-waggons was done. Here was this stately implement forced, like the victim of an implacable conqueror, to carry the materials for its own undoing. It was not so much that bricks were out of place. True, the delicate lines of the waggon-timbers had been shaped for other uses—for hay or for corn-sheaves, or flour-sacks or roots—but waggons have been used for 'brick-cart' often enough, and no wrong done. But here the shame seemed emphasised by the tractor. Instead of quiet beautiful cart-horses, a little puffing steam-engine was hurrying this captive along, faster than ever farm-waggon was designed to go. The shafts had been removed—as when Samson was mutilated to serve the ends of his masters—and although I couldn't see it, I knew only too well how the timbers would be trembling and the axles fretting at the speed of this unwonted toil. I felt as if pain was being inflicted; as if some quiet old cottager had been captured by savages and was being driven to work on the public road.

George Sturt

THE CARTER'S WORDS

I have often wondered what may have been the origin of some of the curious words, or rather sounds, by which the carter communicates with his horses. 'Woh' for 'stop' is familiar to us all. For going forward the word of command is 'pull up'; this in intelligible, though the words as uttered can hardly be recognised, but the alternatives 'Gee-whee' or 'Gee-whut-ah', or the still more mysterious 'mither-wee' ('come to me' or 'turn around'), seem to be outside the bounds of either etymology or syntax. And these curious words are not exactly pronounced; they are produced with a rumbling, cavernous-sonorous kind of inarticulation, as if they passed through an open throat from the depths of the stomach. Then in 'Gee-whut-ah' the first syllable is about two tones higher than the rest. In 'nither-wee' the second syllable of 'mither' jumps up an octave and comes down again upon the 'wee'; and the whole intonation is so much muffled and broadened that it sounds as if the vowels were 'o' and 'u' instead of 'i' and 'e'. There is also a suspicion of the jodelling trick about it. But it is one of the true old country sounds, and long may it remain in use.

Gertrude Jekyll

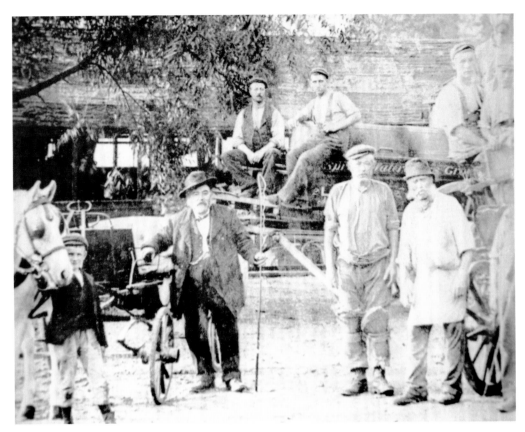

WILLOW FARM, NEAR MITCHAM

THE GRUMBLING FARMER

The return journey to Dorking is best made by the Coldharbour Road, past the 'Plough Inn', for it is all down hill, and only about three miles from the village to the town. On this road I fell into conversation with a man who was walking along by the side of his horse and cart, and whom I found boiling over with complaints about everything on the earth and above it—a true British grumbler. The weather was bad—it was a lovely day in June—and the crops were certain to be bad; England was not worth living in. 'What was the good of trying to farm in such a country as this, where everything is either scorched up with the sun or drownded with the rain?' And so he went on. I thought of a little account of farming in another land which I had read a little while before and when I went home I hunted it out, and read it again, and wished I could hear what my discontented friend on the road would have to say to it. It is from the *Golden Transcript*, a Colorado paper; and although the account of farming difficulties in that rich State is written in the half-comic vein so dear to American journalist, yet the difficulties themselves are not in the least exaggerated. Thus it runs; 'The farmers in the vicinity are having a pleasant time now. At daylight they get up and examine the holes around the cornhills for cut-worms; then smash coddling moth larvae with a hoe handle until breakfast. The forenoon is devoted to watering the potato bugs with a solution of Paris green, and after dinner all hands turn out to chase with flail and broom the festive grasshopper. In the evening a favourite occupation is sitting on the fence figuring how much they would have made had it not been for the bugs; and after a brief season of devotion at the shrine of the night-flying coleoptera, all the folks retire and sleep soundly till Aurora reddens the east, and the grasshoppers tinkle against the window-panes, and summon them to the labours of another day.' Life in England may have its drawbacks, but has any man yet discovered the country where there are none? If so, I wish he would communicate with me.

Louis Jennings

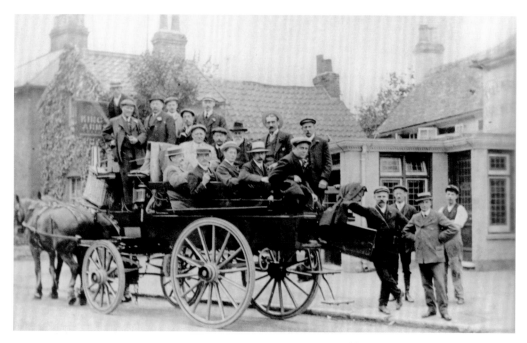

THAMES STREET, WEYBRIDGE

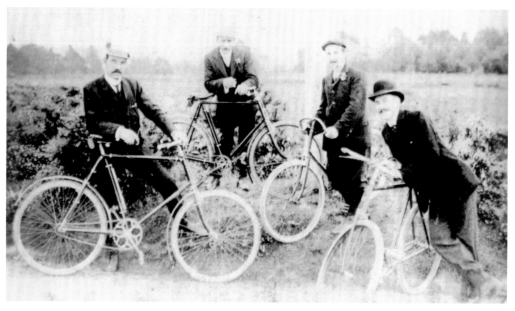

A GENTLEMEN'S OUTING

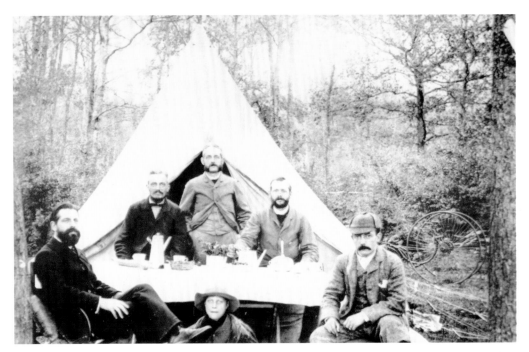

A PICNIC IN THE WOODS

SUBURBS

People who live in London, and those who live in the depths of the country, are both equally inclined, for different reasons, to laugh a little, and even sneer, over the obvious disadvantages of suburban residences. By suburban I mean more the character of the surroundings than the actual distance from London or any other large town. The more favoured a place is as regards soil and climate, the more thickly populated it becomes. But the near neighbourhood of London has certainly immense advantages under many conditions. For young couples, if a man is strong and well, and has work to do in town, it is the very poetry of life compared to London itself, and is a phase of existence which a woman, if once she has had it, always looks back upon with pleasure. She has her children and her duties all day, and in the evening the man throws off his bothers and worries and comes back to peace and happiness, rest and pure air at home. When children get big, and have tastes and talents of their own which must be developed and educated, there is certainly much to be said in favour of moving the home for some years to London. When the parents are no longer young, and when, however friendly they may be and proud of each other, they have to pursue individually their own lives, and carry out that partnership which is the only perfect form of middle-aged married life, for the good of the children and the general well-being of the establishment, then the oneness of married life cannot possibly be carried on without a certain sacrifice of what is best for the growing-up children. But, again, in the evening of life, when friends gradually fall away, and we become rather a duty and perhaps even a slight burden to our children and relations, who have their own lives to attend to, I consider that residing in the suburbs solves, once more, a great many of the difficulties of our complicated family existence. Our children can easily visit us, and, if we are not too old, we can so well go to London for duty or pleasure, and in this way see, and hear, and learn all that is going on. If all this is true, as I think it is, we are saved, without actually living in London, from the reproach that, being buried in the country, we let ourselves go, and grow old prematurely. To be an easy distance from town, though saying this may seem rather a drop from the sublime to the ridiculous, certainly helps us to cultivate the enjoyment of Nature, and, at the same time, gives us the opportunity, if we have the power in however slight a degree, of acquiring knowledge for its own sake without regard to its practical application. Surely these are the only two perfect sources of human happiness? I do not say this thoughtlessly.

Mrs C. W. Earle

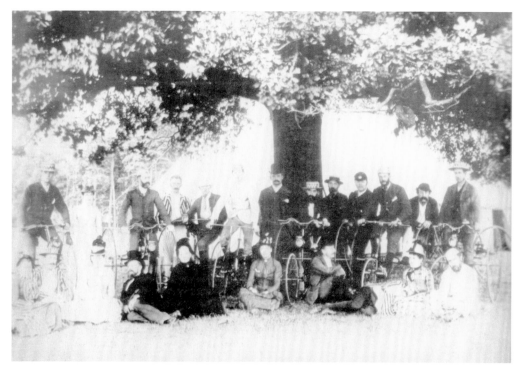

CYCLING CLUB'S DAY OUT

COUNTRY LOVERS

When that sturdy pioneer, John Mayall junior, first rode his velocipede from London to Brighton in 1869, in much physical discomfort, and left his two would-be companions behind him in a crippled condition, no one could have foreseen the days when many thousands of Londoners would with little effort explore the Home Counties on Saturdays or week-ends, and ride sixty or seventy miles a day for the mere pleasure of seeking country lanes and historic spots.

There are, indeed, no more ardent lovers of the country, of scenery, of ancient halls and churches, of quiet hamlets and historic castles than London cyclists, who are often, in fact recruited from the ranks of those pedestrians who, finding they could by means of the cycle extend their expeditions in search of the venerable and the beautiful, have cast away staff and stout walking-boots, and have learnt the nice art of balancing astride two wheels.

So much accomplished, the ex-pedestrian has at once widened his radius to at least thrice its former extent, and places that to him were little known, or merely unmeaning names, have become suddenly familiar. Even the sea—that far cry to the Londoner—is within reach of an easy summer day's ride.

To have visited Jordans, where the early Quakers worshipped and are laid to rest; to have entered beneath the roof of the 'pretty cot' at Chalfont St Giles that sheltered Milton; to have seen with one's own eyes Penshurst, the home of the Sidneys, and Chenies, the resting-place of the Russells; to have meditated beneath the 'yew tree's shade' at Stoke Poges; to have seen or done all these things is to have done much to educate one-self in the historic resources of the much-talked-of but little-known countryside. The King's Stone in Kingston market-place, Caesar's Well on Keston Common, the 'Town Hall' at Gatton, the Pilgrims' Way under the lee of the North Downs, and the monumental brasses of the D'Abernons at Stoke D'Abernon have each and all their engrossing interest; or, if you think them to savour too greatly of the dry-as-dust studies of the antiquary, there remain for you the quaint old inns, the sleepy hamlets, and the tributary rivers of the Thames, all putting forth a never-failing charm when May has come, and with it the sunshine, the leaves and flowers, and the song of the birds.

Charles G. Harper

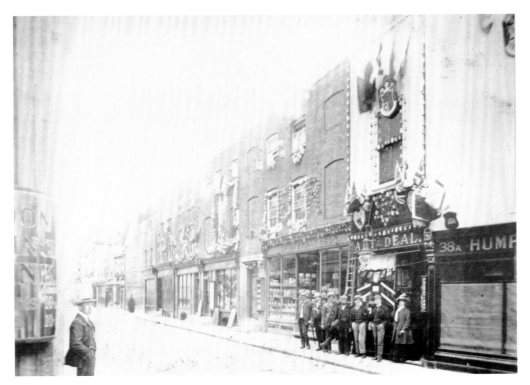

RICHMOND, CHARTER DAY

FAIR RICHMOND

'Richmond enjoys the privilege of beauty still, as in the days when Walpole and King George dined and drank together on a Saturday afternoon, but she has to fight, inch by inch, for every attribute that makes her fair. For the last thirty years her life has been a battle; like many a mortal beauty, every man's hand has been against her. The speculating builder has menaced her loveliest features, and has only been repulsed by the stupendous efforts of those who cherish her. Her islands, her meadows, the slope of her hill, have been fiercely threatened and fiercely defended. Pleasure seekers come to her from the four corners of the earth, and rejoice in the loveliness of a Park which has few rivals in all the width of England—a place so sylvan, a forest so little, and within half an hour's journey of London. When a public resort of exceptional loveliness is in question, surely there is something to be said, not only for Richmond, but also for the Metropolitan million that takes its pleasure through all the changes of the year in the varying beauties of a park that King and Commons, painter and poet alike, have admired and loved.'

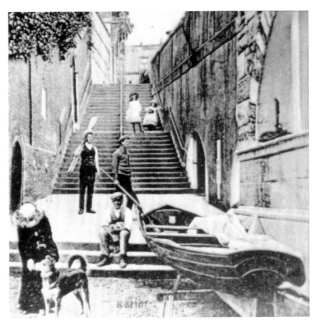

The World, 28 May 1902

THE STEPS, RICHMOND

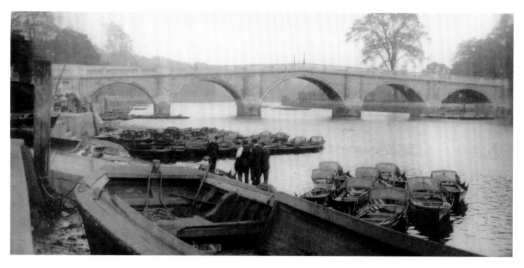

THE RIVERSIDE, RICHMOND

RICHMOND

The civic and municipal affairs of Richmond are managed by a 'Select Vestry', of which the vicar and the local magistrates are *ex-officio* members. They divide themselves into committees for roads and drainage, for the regulation of schools, fire brigade, recreation grounds, public library, buildings, burial grounds, &c.

'Great bodies', however, proverbially 'move slow', and perhaps that is the reason why the vestry has now spent seven years and upwards of seventy thousand pounds upon a well without yet having come to water. This is all the more strange, perhaps, seeing that for the first artesian well dug at Richmond, in the grounds of the Duke of Buccleuch, where the boring was chiefly through a hard blue clay, the water was met with at a depth of 254 feet. Opposite Spring Grove stands an ancient conduit, whence the town was partly supplied with water during difficulties with the Waterworks Company a few years ago.

One of the penalties of the rapid growth of Richmond, one of the most increasing suburbs of London, has lately been a deficiency in the water supply. The artesian well was already pierced to a depth of 1,279 feet, or 845 feet below the original boring. The deficiency is ascribed to a reduction in the amount of rainfall, and the large quantity of water used for trade purposes. Measures have, however, been taken to supply the deficiency.

Richmond, in fact, in common with other London suburbs, has suffered for some time from a deficiency in the water supply. The monopoly of the companies on the one hand, and the incompetency of local authorities on the other, have brought it to such a pass that for days together the supply entirely ceased, and that in the hottest part of summer. The Southwark and Vauxhall Company have offered to provide water at a high charge, but it is full time that measures should be taken by Government to prevent the recurrence of such an event. Mr Frederick Senior, the vestry clerk, in a letter to *The Times*, in March, 1884, with reference to the water-supply of Richmond writes:- 'The vestry, when they undertook the water-supply of the town, had to purchase premises and erect pumping machinery and a reservoir, and lay mains, &c., which works cost altogether some £46,000; but the parish derives an income of nearly £6,500 per annum therefrom (being the produce of a 1s. water rate, assessed on the rateable value of the houses supplied, and certain minor receipts), whereof £2,500 per annum defrays all working expenses, &c., and the £4,000 per annum balance goes in repayments of the principal and interest of the money borrowed on the authority of the Local Government Board to construct the works, and repayable in thirty years; while in other respects Richmond rates are now as follows:- Poor rate, 1s. 6d. per annum; highway and general rate, including free library and every other expense, 2s. 2d., per annum—grand total 3s. 8d., per annum.'

The drainage system of the town was perhaps quite adequate to the wants of the population when it was first carried out; but the speculative builders have done their best to spoil this once charming suburb by erecting so many houses, that the underground arrangements for the carrying away of the sewage are already too small for the requirements of the place.

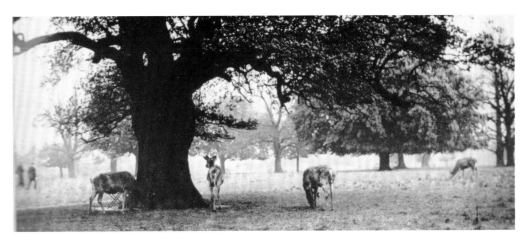

RICHMOND PARK

Of water, however, under other circumstances, the inhabitants of Richmond have sometimes enough and to spare. They are occasionally in the case of the *Ancient Mariner*, with

> Water, water, everywhere,
> And not a drop to drink.

We read in one of the daily papers that 'the Surrey side of the Thames, between Richmond and Kew, was considerably overflown by the tide of this morning, and hundreds of yards of the raised footpath was half carried away into the ha-ha of the Old Deer Park, which now resembles a lake, over one hundred acres being under water: That Richmond is subject to these floods is a well-known fact.

Edward Walford

IN RICHMOND PARK

One afternoon in late summer I was walking with three ladies among the scattered oak trees near the Pen Ponds when we saw a hind, a big beautiful beast, rearing up in her efforts to reach the fully ripe acorns, and on my plucking a few and holding them out to her, she came readily to take them from my hand. She invariably took the acorn with a sudden violent jerk; not that she was alarmed or suspicious, but simply because it was the only way known to a hind to take an acorn from the branch to which it is attached with a very tough stem. To her mind the acorn had to be wrenched from me. My friends also gave her acorns, and she greedily devoured them all and still asked for more.

And while we were amusing ourselves in this way, two ladies accompanied by a little girl of about eight or nine came up and looked on with delight at our doings. Presently the little girl cried out, 'Oh, mother, may I give it an acorn?' And the mother said 'No'. But I said, 'Oh, yes, come along and take this one and hold it out to the deer'. She took it from me gladly and held it out as directed. Then a sudden change came over the temper of the animal; instead of taking it readily she drew back, looking startled and angry; then slowly, as if suspiciously, approached the child and took the acorn, and almost at the same instant sprang clear over the child's head, and on coming down on the other side, struck violently out with her hind feet. One hoof grazed her cheek and dealt her a sharp blow on the shoulder. Then it trotted away, leaving the child screaming and sobbing with pain and fright.

For a few minutes I was amazed at this action of the hind, then I noticed for the first time that the child was wearing a bright red jacket. O unseeing fool that I am, exclaimed I to myself, not to have noticed that red jacket in time! I think my hurt was as great as that of the child, who recovered presently and was duly (and quite unnecessarily) warned by her mother to feed no more deer.

I have seen the effect of scarlet on various other animals, but never before on deer. It affects animals as a warning or a challenge, according to their disposition, and if they are of a fiery or savage temper, it is apt to put them in a rage.

W. H. Hudson

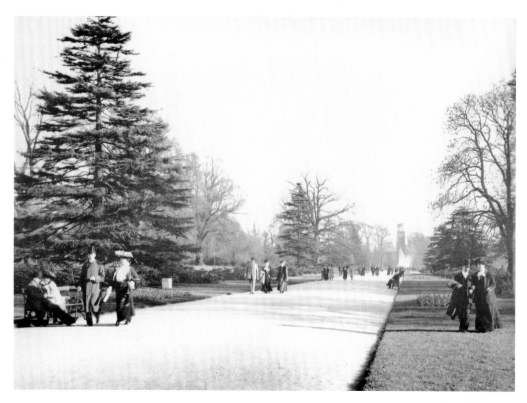

KEW GARDENS

THE DELIGHTS OF KEW GARDENS

A great green book, whose broad pages are illuminated with flowers, lies open at the feet of Londoners. This volume, without further preface, lies ever open at Kew Gardens, and is most easily accessible from every part of the metropolis. A short walk from Kew station brings the visitor to Cumberland Gate. Resting for a moment upon the first seat that presents itself, it is hard to realize that London has but just been quitted.

Green foliage around, green grass beneath, a pleasant sensation—not silence, but absence of jarring sound—blue sky overhead, streaks and patches of sunshine where the branches admit the rays, wide, cool shadows, and clear, sweet atmosphere. High in a lime tree, hidden from view by the leaves, a chiffchaff sings continually, and from the distance comes the softer note of a thrush. On the close-mown grass a hedge-sparrow is searching about within a few yards, and idle insects float to and fro, visible against the background of a dark yew tree—they could not be seen in the glare of the sunshine. The peace of green things reigns.

It is not necessary to go farther in; this spot at the very entrance is equally calm and still, for there is no margin of partial disturbance—repose begins at the edge. Perhaps it is best to be at once content, and to move no farther; to remain, like the lime tree, in one spot, with the sunshine and the sky, to close the eyes and listen to the thrush. Something, however, urges exploration.

The majority of visitors naturally follow the path, and go round into the general expanse; but I will turn from here sharply to the right, and crossing the sward there is, after a few steps only, another enclosing wall. Within this enclosure, called the Herbaceous Ground, heedlessly passed and perhaps never heard of by the thousands who go to see the Palm Houses, lies to me the real and truest interest of Kew. For here is a living dictionary of English wild flowers.

The meadow and the cornfield, the river, the mountain and the woodland, the seashore, the very waste place by the roadside, each has sent its peculiar representatives, and glancing for the moment, at large, over the beds, noting their number and extent, remembering that the specimens are not in the mass but individual, the first conclusion is that our own country is the true Flowery Land.

IN THE GREENHOUSE

But the immediate value of this wonderful garden is in the clue it gives to the most ignorant, enabling any one, no matter how unlearned, to identify the flower that delighted him or her, it may be, years ago, in far-away field or corpse. Walking up and down the green paths between the beds, you are sure to come upon it presently, with its scientific name duly attached and its natural order labelled at the end of the patch.

Had I only known of this place in former days how gladly I would have walked the hundred miles hither! For the old folk, the aged men and countrywomen, have for the most part forgotten, if they ever knew, the plants and herbs in the hedges they had frequented from childhood. Some few, of course, they can tell you; but the majority are as unknown to them, except by sight, as the ferns of New Zealand or the heaths of the Cape.

Since books came about, since the railways and science destroyed superstition, the lore of herbs has in great measure decayed and been lost. The names of many of the commonest herbs are quite forgotten—they are weeds, and nothing more. But here these things are preserved; in London, the centre of civilization and science, is a garden which restores the ancient knowledge of the monks and the witches of the villages.

Richard Jefferies

GARDENERS' CORNER

Traps for Slugs—Old bones and lettuce leaves are dainties no slug can resist. Put them out in the early evening and last thing candle in hand, sally forth and 'Kill, kill, kill'. For this purpose a jar of strong brime is the least objectionable mode. A circle of dry bran laid round a plant will often preserve it from these persistent raiders; they love bran and it appears to have a stupefying effect upon them, but loses its virtue in damp and rainy weather.

The Surrey County Magazine, c. 1900

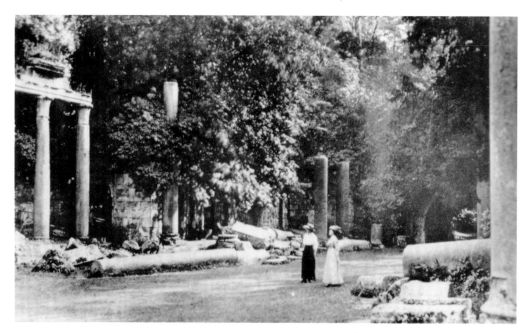

THE RUINS, VIRGINIA WATER

NEAR WINDSOR GREAT PARK

A gate in the wooden fence beside the inn opens immediately to the lake. The boys who hang about this gate and sell green apples, of which the very sight is almost sufficient to induce stomach-ache, tell the unwary that cycles are not allowed within, thereby deceiving many, and earning innumerable twopences for 'minding' the machines. It is well to disregard what they have to say, and to manoeuvre the cycle through the gate. Here we are within the bounds of Windsor Great Park. Directly in front stretches the beautiful sheet of water, said, on insufficient authority, to be 'the largest artificial lake in England'. It is, however, very large: one and a half miles long, and with two arms, each half a mile in length. It was formed considerably over a hundred years ago by intercepting the waters of the Bourne, a little stream rising near Ascot and falling into the Thames at Chertsey, and by damming them in a natural hollow. The general idea was originated by the Duke of Cumberland, and the design was that of Paul Sandby, one of our early water-colourists. The name given to the lake derives from the Duke of Cumberland being at the time Governor of Virginia.

Surrounded on every side by dense woods of solemn pines, the place is very impressive. Turning to the left, and following the grassy shore for a little way, turn down a road bearing to the left again, away from the water. This leads down to the waterfall, down which the waters of the Bourne splash on their way to liberty and the Thames. The fall is made of great masses of rock piled up ingeniously to resemble a natural ravine. Shaded by trees and fringed by rushes, the scene is really very pretty. The rough stone bridge whence you view it, formed of immense slabs of rock, is not unlike those early British bridges found on Dartmoor—only more elaborate. If only this were not a modern imitation, how professional antiquaries would rave about it, to be sure!

Crossing this, and coming up a rise, one reaches the famous 'ruins' by continuing ahead, by the shores of the lake. They stand on a broad lawn stretching away back from the water, and were built to resemble a ruined temple. They are thus sham ruins, and, knowing that, the visitor perversely refuses to receive the romantic thrill otherwise appropriate; which shows that picturesqueness is a matter more of sentiment than of form. As a matter of fact, the columns themselves are genuine antiques, from Corinth and from Tunis, the spoils of ruined temples of those sunny climes, brought here to moulder in the damp and rigours of a northern climate. The 'ruins' themselves are growing ruinous, for two of the most picturesque of the Corinthian columns, with their architrave, have recently fallen, and lie, a confused heap, on the grass amid the other prostrate stones carefully arranged in disorder over a century since.

Charles G. Harper

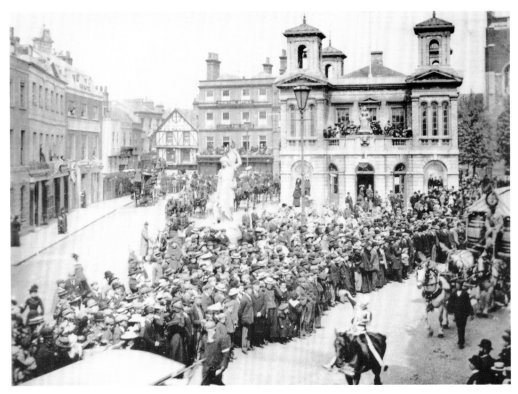

CHARTER CELEBRATIONS, MARKET PLACE, KINGSTON

CELEBRATING KINGSTON'S FIRST CHARTER

The Celebration of the 700th anniversary of the granting of the first charter to Kingston by King John which was held on Wednesday last, was so far successful that one could not help regretting that the time for preparation had been so short. For if in little more than a week so much was accomplished what could not have been done if the time in preparation had been say a month? There are not wanting cynical people who, possessed by the ultra utilitarian spirit of the age, cry *Cui bono*? What is the use of making all this fuss about something that happened 700 years ago?. . .

A considerable amount of anxiety has been felt as to whether, in the very short time available for preparation, it would be possible to carry out a procession in any sense worthy of so interesting and historical an occasion. But the difficulties were faced with resolution and enthusiasm, and the result was highly creditable to all concerned. The procession was long enough in all conscience, extending as it did for over a mile; nor was there any lack of variety, for there were three very pretty tableaux, arranged on cars, several highly effective industrial cars, and vans and carts of all classes and descriptions, representing various aspects of commercial activity, from that of chimney sweep to the cycle manufacturer, while brewers and mineral water manufacturers were well to the fore in showing what they could do. And there was one motor car. Most of the turn-outs were admirable, and the horses were quite a feast for the admirers of well-bred, well fed and well-groomed cattle.

The Surrey Comet, 29 April 1899

AN IMPOSING PAGEANT

Whit-Monday was properly chosen as the day most fitting for the public rejoicing, for being Bank-Holiday, most people were free to participate in the festivities. The Morning broke dull and grey. Ominous-looking clouds that might have carried snow, so cold was the air, swept across the sky impelled by the force of a stiff Nor'easterly breeze, but shortly before nine o'clock Old Sol peeped shyly through a rift in the heavy vaporous bank, and his

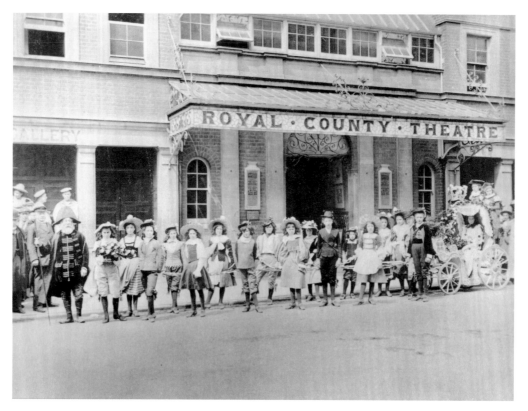

MILLENARY PROCESSION, KINGSTONE

re-assuring smile revived all drooping spirits. Neither was this early promise of a fine morning disappointed, for though an occasional slight shower fell to help to lay the dust which the gusty wind raised in dense clouds, making people yearn for the sight of the Corporation watering-carts, there were long bright sunny intervals.

The programme for the day commenced with a grand street procession of emblematic cars, trade vehicles, historical characters, decorated cycles, etc. The organising committee had made admirable arrangements for marshalling their forces, the selected venue being Lower Harm-road, and Ceres-road. All taking part in the procession were required to proceed to their stations via the Richmond-road and Lower King's-road, where they received their instructions as to position from the Point Marshals, Captain D. Macrostie, and Councillor Sprunt. Start from Kingston railway station. . . returning by the London-road to Fairfield West, which proved a convenient spot for breaking-up.

As a spectacle the pageant surpassed everything of the kind ever attempted in the borough in past times. The tradesmen came out strong with decorated vehicles, upon which were given practical demonstrations of the crafts represented; there was a brave show of emblematic cars; and there were many novel features introduced. It was indeed a brilliant show, and as instructive—shewing the advance of the times in the trades section—as it was pleasing. It seems invidious to particularize, yet special mention must be made of some of the vehicles that claimed attention on account of the elaboration, originality, and general excellence of their design. Little time, thanks to the marshals, was lost in lining up the procession, which extended over a mile in length, and at about eleven o'clock just in time to avoid the heavy traffic proceeding to the Hurst Park races, the cavalcade moved off, amid the cheers of the assembled multitude outside the railway station. Every street traversed was thickly lined with spectators and the windows of the houses en route were at a premium. Expressions of admiration were heard on all sides as the magnificent pageant slowly passed. Many of the thoroughfares were gay with bunting, which lent additional colour to the display.

Special Souvenir Issue of the Millenary of the Coronation of King Edward the Elder, 1902

MAY, 1902.

THE

Price **3d.**

"SURREY COMET"

SPECIAL

SOUVENIR

NUMBER

ISSUED IN CONNECTION WITH THE

MILLENARY

Of the Coronation

of

A.D.
902.

A.D.
1902.

TAKEN FROM M.S.
IN THE BRITISH MUSEUM

King Edward the Elder.

King Edward the Elder,

At KINGSTON-UPON-THAMES.

THE CORONATION STONE
AT KINGSTON-UPON-THAMES.

List of Contents.

Numerous Illustrations

KINGSTON-UPON-THAMES:
KNAPP, DREWETT & SONS, LIMITED, PRINTERS AND PUBLISHERS,
"SURREY COMET" OFFICE, AND 37, MARKET PLACE.

SOUVENIR ISSUE OF THE *SURREY COMET*

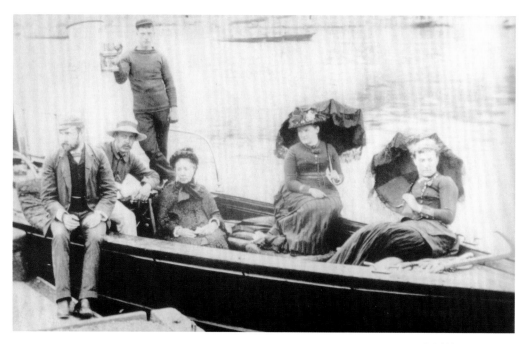

BOATING PARTY

ON THE THAMES

… Each of these Thames-side towns is a haven for escaped Londoners, often familiar with little more of them than the boat-houses on their banks, and the inns, some of which seem too eager to make their hay while the sun shines. Each has its fleet of boats, moored thickly together in whole rafts, its clubs, and its annual gala day of the local regatta. On a fine Sunday or Saturday afternoon every lock is packed with youth and beauty, set off by gay colours and airy costumes. Every reach within railway ride of London may be found lively with a jumble of craft of all sorts, from Canadian canoes to Venetian gondolas, tiny yachts, skiff's, tubs, outriggers, punts, ferryboats, eiths, fours, 'dongolas', 'randans', pairs, rowed, poled, tugged, towed, or idly moored, like the big houseboats whose cramped luxury gives a lazy refuge from cares and taxes. Among all these the barges of business move like surly and clumsy tyrants; and water-scorching machines sweep through the fluttered crowd as wolves in a sheepfold. Steamers and motor-launches have replaced the State barges in which Lord Mayors and such-like used to progress in the days when to be a jolly young waterman' was more of a trade than a pleasure.

> Those flights upon the banks of Thames,
> That so did take Eliza and our James—

were winged by mercenary arms. It seems well that the golden or gilded youth of our generation are more active, taking their amusement *moult tristement*, as might be judged by all unsympathetic foreigner. An English writer has found fault with Thames boats as 'built for woman and not for man, for lovely woman to recline, parasol in one hand and tiller ropes in the other, while man—inferior man—pulled and pulled and pulled as an ox yoked to the plough'. But that is hardly fair now that girls boyishly take their turn at the oar, even exhibiting the spectacle of whole galleys deftly wommanned by crews of water-Amazons. The only right left to man here is the panting and perspiring toil of the tow-path, to which he bends devotedly like 'the captives depicted on Egyptian monuments with cords about their necks'. Such slavery may well be preferred to the aid of those exhorbit and foulmouthed hirelings who infest the river banks in search of a job, which to Edwin makes a labour of love, so Angelina be drawn along cool, at ease, grateful, and admiring. With his dynamic energy, contrast the contemplative, perhaps misanthropic, and apparently celibate joys of the angler, throned upon his punt or posted on the bank, as he has been ever since Pope's day.

A. R. Hope Moncrieff

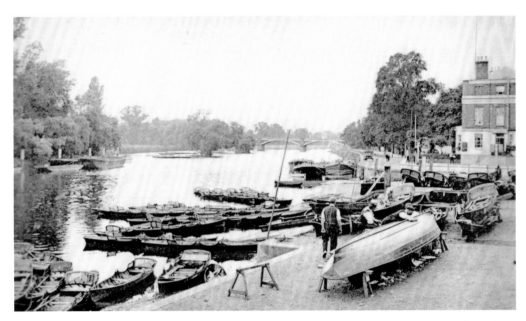

THE WATERSIDE, RICHMOND

A SUPERIOR FORCE

By-and-by, I began to question if rowing on a river is as pleasant as rowing on a lake, where you can rest on your oars without losing ground, where no current opposes progress, and after the stroke the boat slips ahead some distance of its own impetus. On the river the boat only travels as far as you actually pull it at each stroke; there is no life in it after the scull is lifted, the impetus dies, and the craft first pauses and then drifts backwards. I crept along the shore, so near that one scull occasionally grounded, to avoid the main force of the water, which is in the middle of the river. I slipped behind eyots and tried all I knew. In vain, the river was stronger than I, and my arms could not for many hours contend with the Thames. So faded another part of my dream. The idea of rowing from one town to another—of expeditions and travelling across the country, so pleasant to think of—in practice became impossible. An athlete bent on nothing but athleticism—a canoeist thinking of nothing but his canoe—could accomplish it, setting himself daily so much work to do, and resolutely performing it. A dreamer, who wanted to enjoy his passing moment, and not to keep regular time with his strokes, who wanted to gather flowers, and indulge his luxurious eyes with effects of light and shadow and colour, could not succeed. The river is for the man of might.

Richard Jefferies

CAMPING OUT

We arranged to start on the following Saturday from Kingston. Harris and I would go down in the morning, and take the boat up to Chertsey, and George, who would not be able to get away from the City till the afternoon (George goes to sleep at a bank from ten to four each day, except Saturdays, when they wake him up and put him outside at two), would meet us there.

Should we 'camp out' or sleep at inns?

George and I were for camping out. We said it would be so wild and free, so patriarchal like.

Slowly the golden memory of the dead sun fades from hearts of the cold, sad clouds. Silent, like sorrowing children, the birds have ceased their song, and only the moorhen's plaintive cry and the harsh croak of the corncrake stirs the awed hush around the couch of waters, where the dying day breathes out her last.

From the dim woods on either bank, Night's ghostly army, the grey shadows, creep out with noiseless tread to chase away the lingering rearguard of the light, and pass, and noiseless, unseen feet, above the waving river-grass, and through the sighing rushes; and Night, upon her sombre throne, folds her black wings above the darkening

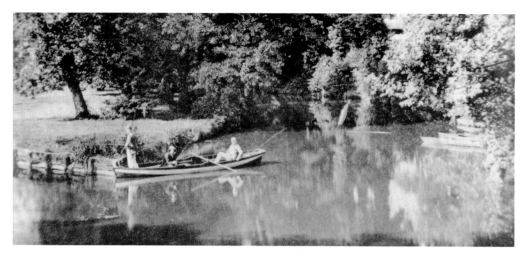

RIVER MOLE

world, and, from her phantom palace, lit by the pale stars, reigns in stillness.

Then we run our little boat into some quiet nook, and the tent is pitched, and the frugal supper cooked and eaten. Then the big pipes are filled and lighted, and the pleasant chat goes round in musical undertone; while, in the pauses of our talk, the river, playing round the boat, prattles strange old tales and secrets, sings low the old child's song that it has sung so many thousand years—will sing so many thousand years to come, before its voice grows harsh and old—a song that we, who have learnt to love its changing face, who have so often nestled on its yielding bosom, think, somehow, we understand, though we could not tell you in mere words the story that we listen to.

And we sit there, by its margin, while the moon, who loves it too, stoops down to kiss it with a sister's kiss, and throws her silver arms around it clingingly; and we watch it as it flows, ever singing, ever whispering, out to meet its king, the sea—till our voices die away in silence, and the pipes go out—till we, commonplace, everyday young men enough, feel strangely full of thoughts, half sad, half sweet, and do not care or want to speak—till we laugh, and, rising, knock the ashes from our burnt-out pipes, and say 'Good night', and, lulled by the lapping water and the rustling trees, we fall asleep beneath the great, still stars, and dream that the world is young again—young and sweet as she used to be ere the centuries of fret and care had furrowed her fair face, ere her children's sins and follies had made old her loving heart—sweet as she was in those bygone days when, a new-made mother, she nursed us, her children, upon her own deep breast—ere the wiles of painted civilization had lured us away from her fond arms, and the poisoned sneers of artificiality had made us ashamed of the simple life we led with her, and the simple, stately home where mankind was born so many thousands of years ago.

Harris said:

'How about when it rained?'

You can never rouse Harris. There is no poetry about Harris—no wild yearning for the unattainable. Harris never 'weeps, he knows not why'. If Harris's eyes fill with tears, you can bet it is because Harris has been eating raw onions, or has put too much Worcester over his chop.

If you were to stand at night by the seashore with Harris and say:

'Hark! Do you not hear? Is it but the mermaids singing deep below the waving waters; or sad spirits, chanting dirges for white corpses, held by seaweed?'

Harris would take you by the arm, and say:

'I know what it is, old man; you've got a chill. Now, you come along with me. I know a place round the corner here, where you can get a drop of the finest Scotch whisky you ever tasted—put you right in less than no time.'

Harris always does know a place round the corner where you can get something brilliant in the drinking line. I believe that if you met Harris up in Paradise (supposing such a thing likely), he would immediately greet you with:

'So glad you've come, old fellow; I've found a nice place round the corner here, where you can get some really first-class nectar.'

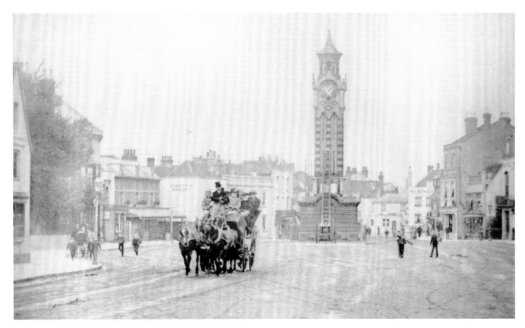

EPSOM HIGH STREET

In the present instance, however, as regarded the camping out, his practical view of the matter came as a very timely hint. Camping out in rainy weather is not pleasant.

Jerome K. Jerome

AROUND EPSOM

Ewell is a convenient starting-point for this trip for South Londoners, and has the additional advantage of being served by two railways. Only in the spring of the year, when the Epsom races are on, and the Derby brings riotous crowds down by road as well as rail, do Ewell and Epsom wake out of their customary quiet. For the rest of the year they are old-fashioned places, even in these villa-building latter days. Ewell, as its name in some sort implies, is a place of springs and running waters, with crooked streets and with an ancient ivymantled church tower, all that is left of the old parish church, standing solemn beside the modern building. Just inside the churchyard gate notice a stone to one who lost his life by falling from a horse at Shipton-under-Wychwood, Oxon; and, close by, a monument with urn and a kneeling figure in relief on a pedestal to James Lowe, born 1798, who 'met his death from an accident the 12th October 1866. He was the inventor of the segments of the screw-propeller, in use since 1838, and his life, though unobtrusive, was not without great benefit to his country. He suffered many troubles, but bore them lightly.'

Epsom, 'town' we should presumably call it, a mile and a half down the road, hints little or nothing to the passing cyclist of its horse-racing fame, save perhaps for stray glimpses gained
of the great Grand Stand perched upon the windy Downs, more than a mile away to the left; and if little be told by external appearances of this intimate relation with the foremost classic race in England, still less would the stranger gather that Epsom is a Place with a Past; a past, as a fashionable Spa, scarce inferior to Bath in the days of good Queen Anne. Epsom wells and Epsom salts have had their day and ceased to be.

Surburbia is extending its frontiers in this direction, and breezy Ashtead, two miles farther on, down a pleasant road, is now set within the marches of the suburbs, where the opposing camps of market gardeners and speculative builders are pitched cheek by jowl, and bricks and plaster are banishing the broccoli and the peas. At Leatherhead the incursions of villadom are lost in the intricacies of the old-fashioned little town and in the embowering foliage that owes its density to that beautiful stream, the Mole. Leatherhead is situated at the junction of many roads. It is what military men would call a 'strategical point', and, touring on a cycle through

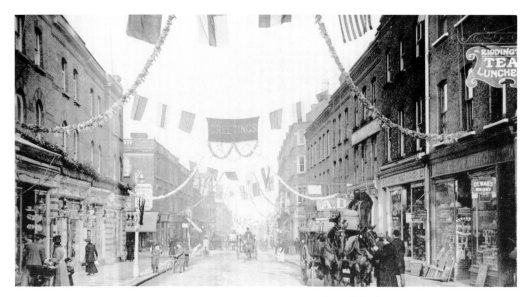

CHRISTMAS, SUTTON HIGH STREET

the southern and south-western districts outside London, you come to it, whether you will it so or not, again and again. And, just because it is a pleasant place, you do not regret the necessity.

Charles G. Harper

SNIPPET

> Sutton for mutton,
> Carshalton for beef,
> Croydon for a pretty girl,
> And Mitcham for a thief
> Anon.

It may be that Mitcham got this bad reputation through the gypsies that long hung about it, and other undesirable aliens who gathered to the revels of Mitcham Fair.

A. R. Hope Moncrieff

CORRESPONDENCE CORNER

The Thames trout-fishing has commenced; but, at the time of writing the coldness of the weather keeps the fish below the surface and prevents them feeding. Several however, are of from 4lbs to 5lbs have been taken, Mr Hobbs of Henley-on-Thames, being at the top of the list with one of 10lbs.

'Straw Hat'

On the 17th December I walked over to Caesars Well, Wimbledon Common. Skating was in full swing on Kingsmere Pond, which gives an idea of the temperature. I paused to look at the clear water of the well, and distinctly saw it giving off a *vapour*. The water was perfectly warm. This may interest those who frequent the Common.

(Unsigned)

Can you inform me what Surrey industries are carried on in the Basin of the Wandle?

Manufacturer

Where in the County is the largest stretch of level ground for a cycle run?

One who can't hill-climb

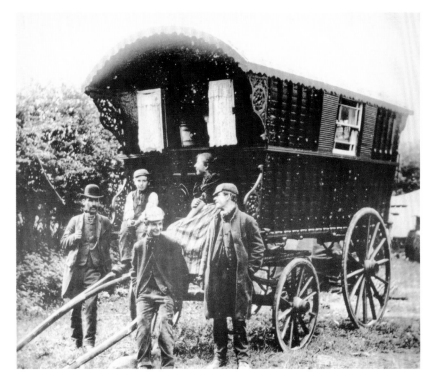

GYPSY CARAVAN, ROWLEDGE

Respecting the query of E.A.A. regarding the Silent Pool, I may say that is not its real name. It is Sherborn Pond, and only took the slang name now given to it from being so called by M.F Tupper in his tale of 'Stephen Langton'. The water is clear because it is fed by springs that issue from the foot of the chalk but since the opening of the new waterworks on the other side of the hill, towards Clandon, the supply is much abated, and the pond may eventually dry up. It is much altered in appearance of late years, since it lost its primitive surroundings.
W. B.

The Surrey Comity Magazine, 1899–1902

NOWHERE TO GO

And those lone wayside greens, no man's gardens, measuring a few feet wide but many miles in length—why should they be used either as receptacles for the dust of motor-cars or as additions to the property of the landowner who happens to be renewing his fence? They used to be as beautiful and cool and fresh as rivers, these green sisters of the white roads—illuminated borders of many a weary tale. But now, lest there should be no room for the dust, they are turning away from them the gipsies who used to camp there for a night. The indolent District Council that is anxious to get rid of its difficulties—for the moment—at the expense of a neighbouring district—it cares not—will send out its policeman to drive away the weary horses and sleeping children from the acre of common land which had hitherto been sacred—to what?—to an altar, a statue, a fountain, a seat?—No! to a stately notice-board; half a century ago the common of which this is a useless patch passed on easy terns to the pheasant lords. The gipsies have to go. Give them a pitch for the night and you are regarded as an enemy of the community or perhaps even as a Socialist. The gipsies shall be driven from parish to parish, and finally settle down as squalid degenerate nomads in a town where they lose what beauty and courage they had, in adding to the difficulties of another council. Yet if they were in a cage or a compound which it cost money to see, hundreds would pay for a stare at their brown faces and bright eyes, their hooped tents, their horses, their carelessness of the crowd, and in a few years an imitation of these things will be applauded in a 'pageant' of the town which has destroyed the reality.

Edward Thomas

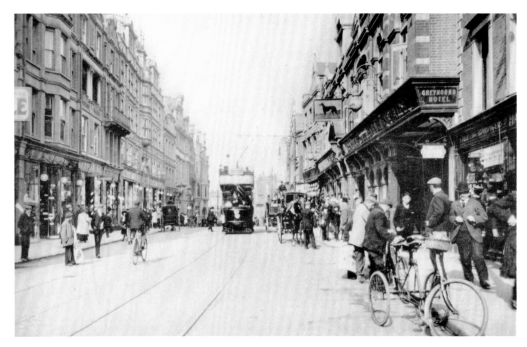

HIGH STREET, CROYDON

A HOMELY AUNT

My grandfather was killed at two-and-thirty, by trying to ride, instead of walk, into Croydon; he got his leg crushed by his horse against a wall; and died of the hurt's mortifying. My mother was then seven or eight years old, and, with her sister, was sent to quite a fashionable (for Croydon) day-school, Mrs Rice's where my mother was taught evangelical principles, and became the pattern girl and best needlewoman in the school; and where my aunt absolutely refused evangelical principles, and became the plague and pet of it.

My mother, being a girl of great power, with not a little pride, grew more and more exemplary in her entirely conscientious career, much laughed at, though much beloved, by her sister; who had more wit, less pride, and no conscience. At last my mother, formed into a consummate housewife, was sent for to Scotland to take care of my paternal grandfather's house; who was gradually ruining himself, and who at last effectually ruined, and killed, himself. My father came up to London; was a clerk in a merchant's house for nine years, without a holiday; then began business on his own account, paid his father's debts; and married his exemplary Croydon cousin.

Meantime my aunt had remained in Croydon, and married a baker. By the time I was four years old, and beginning to recollect things,—my father rapidly taking higher commercial position in London,—there was traceable—though to me, as a child wholly incomprehensible,—just the least possible shade of shyness on the part of Hunter Street, Brunswick Square, towards Market Street, Croydon. But whenever my father was ill,—and hard work and sorrow had already set their mark on him,—we all went down to Croydon to be petted by my homely aunt; and walk on Duppas Hill, and on the heather of Addington.

My aunt lived in the little house still standing—or which was so four months ago—the fashionablest in Market Street, having actually two windows over the shop, in the second storey; but I never troubled myself about that superior part of the mansion, unless my father happened to be making drawings in Indian ink, when I would sit reverently by and watch; my chosen domains being, at all other times, the shop, the bakehouse, and the stones round the spring of crystal water at the back door (long since let down into the modern sewer); and my chief companion, my aunt's dog, Towzer, whom she had taken pity on when he was a snappish, starved vagrant; and made a brave and affectionate dog of which was the kind of thing she did for every living creature that came in her way, all her life long.

Contented, by help of these occasional glimpses of the rivers of Paradise, I lived until I was more than four years

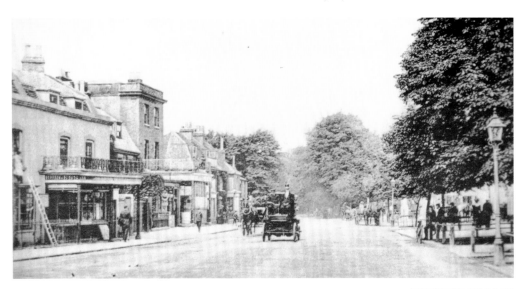

DULWICH VILLAGE

old in Hunter Street, Brunswick Square, the greater part of the year; for a few weeks in the summer breathing country air bv taking lodgings in small cottages (real cottages, not villas. so-called) either about Hampstead, or at Dulwich, at 'Mrs Ridley's', the last of a row in a lane which led out into the Dulwich fields on one side, and was itself full of buttercups in spring, and blackberries in autumn. But my chief remaining impressions of those days are attached to Hunter Street. My mother's general principles of first treatment were, to guard me with steady watchfulness from all avoidable pain or danger; and, for the rest, to let me amuse myself as I liked, provided I was neither fretful nor troublesome. But the law was, that I should find my own amusement. No toys of any kind were at first allowed;—and the pity of my Croydon aunt for my monastic poverty in this respect was boundless. On one of my birthdays, thinking to overcome my mother's resolution by splendour of temptation, she bought the most radiant Punch and Judy she could find in all the Soho bazaar—as big as a real Punch and Judy, all dressed in scarlet and gold, and that would dance, tied to the leg of a chair. I must have been greatly impressed, for I remember well the look of the two figures, as my aunt herself exhibited their virtues. My mother was obliged to accept them; but afterwards quietly told me it was not right that I should have them; and I never saw them again. . ..

John Ruskin

EARLY RISING

'Pot-Pourri' would miss piquancy had it left severely alone the Mistresses and servants difficulty. There is much that appeals to our common-sense in the remarks upon that deadly-dull servant question. Take for instance, one or two of those on early rising; 'An eternal complaint against servants is about early rising. I believe a number of people have no doubt that fifty or sixty years ago (which is I fancy, the time when rather young people think old-fashioned servants lived) they all got up early. We are certainly not the worst among the nations, but I do think that late rising amounts almost to a national fault. These things are greatly the result of climate; but to insist on maids getting up in the dark when there is very little to do, and to give the order that the kitchen fire is to be lit at 6.30, when the family do not breakfast till 9 or half-past seems to me almost tyrannical, though we have a perfect right to expect that the water should be hot and the breakfast ready at whatever time we choose to order it. For two months in the winter I always postpone the breakfast hour from 8 to half-past and I always use (for health reasons) cold water all the year round; but I never have the slightest difficulty in getting breakfast punctually at 8, though I feel quite sure of one thing that if I did not get up early no one else would. It seems a relief to sue people's consciences to insist on the early rising of others when they lie in bed late themselves.'

Mrs C. W. Earle

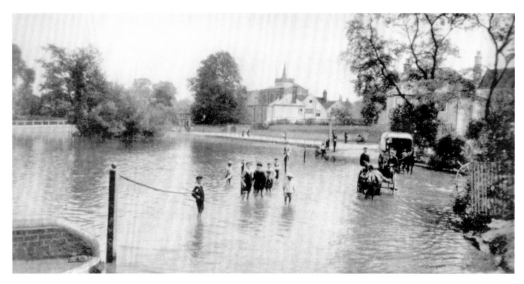

CARSHALTON POND

THE WANDLE

The little river Wandle appeals to all who love the face of Nature. It wanders through many varied scenes, sometimes in the midst of fields, sometimes by the road-side, sometimes through private and sequestered grounds. Often it divides its waters holding little islands in its silvery embrace, and flows on to new and pleasant places. Now and again it widens into an expanse or lakelet while here and there some obstacle in its course creates a waterfall. Its still waters, though nowhere deep are transparent and reflect the sky and all that stands or lives beside them.

The Wandle tells to those who, not content with looking into the face of Nature, must ever be asking her questions, of a dim past; how in its youth it was a mountain-stream of vigour transversing a country not unlike the land of Hiawatha.

To the Antiquary and the Student of History, the Wandle speaks of vanished races of men who have left their foot-prints beside it, of our ancient forefathers who lived and died in its vicinity and of others dwelling near its course who had their share in the making of modern Britain.

For the Sociologist our river has a particular interest, a multitude of industries, dependent upon its waters for their life, having grown up along its banks in the course of a thousand years.

To those who live in the southern parts of London the Wandle brings memories of the country-side and offers sweet oasis in their midst; an offer which, thanks to the Society for the preservation of its beauties, has already been in part accepted.

Lastly, the Wandle, only eleven miles long yet full of manifold interest, has an especial claim upon Surrey people, for it is, from source to outfall, a Surrey river.

John Morrison Hobson

THE SOURCE OF THE WANDLE

. . . At the north end of the street the river Wandle forms the parish boundary, and is spanned by a very pretty, but substantial, iron bridge, which was erected towards the beginning of the present century. Before that time a narrow plank of wood served for foot passengers to pass over, horses and vehicles having to pass through the stream. The river broadens into a lake or pond, opposite the church, just where one would have expected to find the village green. The pond, in the centre of which is a small island, is seldom or never frozen over. This is probably the effect of the numerous springs which feed it, some of which may be seen throwing up small particles of fine sand out of the chalky cavities from. which they issue. The water that flows from deep springs does not easily congeal in winter, just as the feelings of real friendship that flow from the heart are not apt to be frozen by adversity.

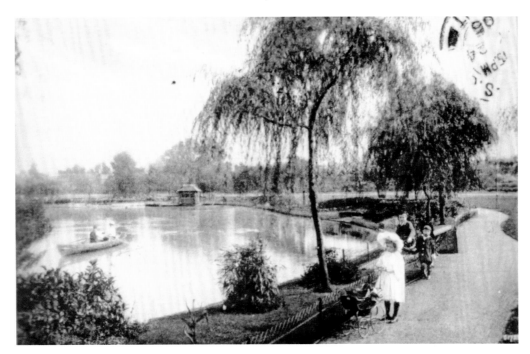

WANDLE PARK, CROYDON

The water, as it issues from its underground home, is so warm as to diffuse a genial heat around, and the atmosphere benefits by it. A writer in *The Times*, who signs himself 'A Carshalton M.D.' states that consumption and other lung diseases are unknown, here, the village being 'probably warmer and healthier than any other place in England'.

Mr Ruskin mentions this clear pond in the preface to his 'Crown of Wild Rivers', (*sic*) expressing his regret at the broken shreds of old metal and rags of putrid clothes which the children are apt to throw into it.

The source of the western branch of the Wandle is to be found in numerous fine springs inside Carshalton Park and in the grounds of Carshalton House. The river here is famous not only for its trout, but for the mills and manufacturing works upon its banks; for in its course of ten miles to Wandsworth, where it falls into the Thames, writes Mr Brightling... 'is carried on a more extensive commerce than perhaps is known in the same compass on any stream of the kingdom'. Stevenson, in his 'Agriculture of Surrey', says that in 1813 there were on it nearly forty mills of different kinds. It is said by Mr E. Jesse and other naturalists that the may-fly is not found in the Wandle here or at Beddington; the presence of the caddis (Phrygania) appearing to drive it away.

This river is mentioned by Pope in his description of the 'Sea-born Brothers of the Thames'; and it is related by Camden that the 'Vandal is augmented by a small river from the east, which arises at Croydon, from Craydiden, lying under the hills'. In a map of the county, published as late as the last century, the name of this river is given as the 'Vandalis'. It may be added that the valley of the Wandle has evidently been the bed of a much larger river in the prehistoric period.

Edward Walford

AROUND THE WANDLE

John Ruskin has told us how the 'cres-set rivulets' of old Croydon helped to mould his infant mind. The highest watercress beds are now just below the fords at Beddington and there are many such along the course of the Wandle, as we have seen in our descent of the stream. When we hear the poor men crying 'water-creases' in the dusty streets of London, using, haply, the old English sound (A.S. crease), our minds are taken back to the 'blue transparent Vandalis' where, perchance, they grew.

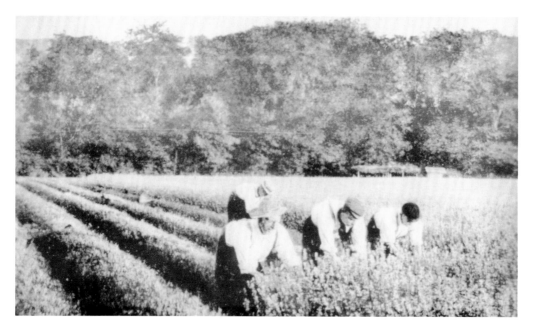

PICKING LAVENDER

We have already alluded to the growing of lavender, peppermint and other pot-herbs of Mitcham. These plants are also cultivated in the chalky fields of the uplands. Let us take a parting glance at Mitcham as it appeared to our old friend Hassell a hundred years ago. He speaks of the place as being 'in the very centre of some hundred acres of physical herb gardens, besides lavender and peppermint grounds. The scenery round it has a most singular appearance in autumn: the hues of its herbage are particularly diversified, with blue from the ripe lavender; red and brown from the herbs; rich dark yellow from the wheat; pale yellow and greens of various casts from ripe and unripe barley and oats; purple from seed clovers; and deep brown from the fallow lands. There are few places better adapted for the study of colouring than the surrounding parts of this village.'

John Morrison Hobson

THE MITCHAM DISTILLERS

Mitcham in Surrey, with the land areas in its more or less immediate neighbourhood, has always been the home of the industry that forms the subject of this article, that subject being the distillation of essential oils from peppermint, lavender, pennyroyal, rosemary, chamomile, etc.—a process in which peppermint occupies by far the most important place. The once flourishing business in lavender has been practically killed, primarily because of a foreign competition against which existing conditions make it hopeless to contend.

In obtaining an interview with Messrs. J. & G. Miller, we had the privilege of meeting the largest growers of white peppermint in Great Britain, and the proprietors of the oldest and largest peppermint stills, the firm being also growers and distillers of the other herbs we have enumerated. Growing operations were conducted on an extensive scale by the founder of the enterprise between thirty and forty years ago, and the distillery was established by his sons and successors, Mr James Miller and Mr George Miller.

August marks the beginning of the harvest, from whence through September and into October the work of distillation goes on without intermission day and night (Sundays, of course, excepted). In the case of this establishment, the stills—large in size and four in number—are pot stills of the old fashion, for the proprietors deprecate the use of new stills of the 'patent' type. It was the old pot still that won the Mitcham products their reputation as the best in the world, and what made that reputation should assuredly be retained in order to keep it.

At the time of our visit (last month) the works were of course idle, but an idea of their *modus operandi* can be gathered from the following brief description.

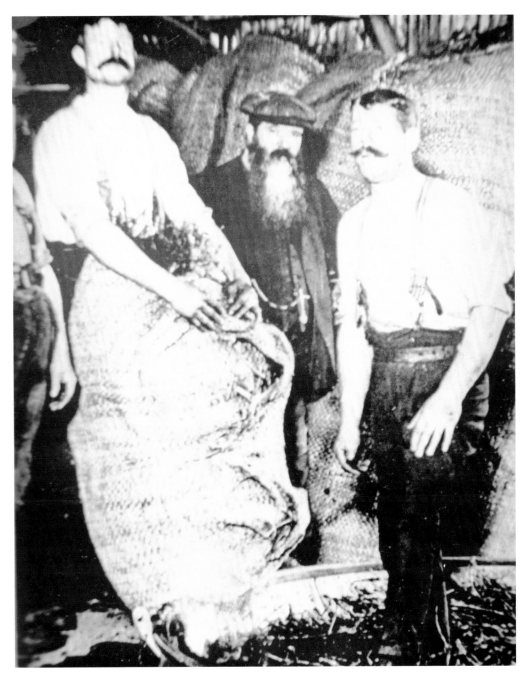

MITCHAM DISTILLERY

The ground floor resembles in appearance an ordinary engine room, but besides the furnaces immense condensing vats are conspicuous with oil receivers at their base, and a copper pan capable of holding 16 cwts of dried herbs, and the necessary quantity of water for distilling, its rim projecting. about 6 feet into the floor above, a large part of which is occupied in the season by 'mats' of peppermint and lavender. These mats are thrown down towards the mouth of the copper, into which the contents are flung and trodden down. The water is increased to within two or three feet of the top, and in about half an hour the distillate begins to come over, when the fires are damped down, and the collection of the distillate is continued for six hours, at the end of which the charge of steaming herb is cleared. For this the men strip to the waist, the work being effected by a combination

DYING CLOTH, WILLIAM MORRIS WORKS

of mechanism and manual labour. Messrs. Miller's premises having been specially built and equipped for the purposes they serve present various features of structural and implemental interest of—necessarily—a purely technical character.

As regards the yield of their big stills it is not possible to give precise statistics, much depending on the state of the herbs, but according to our analysis of certain figures with which we were furnished, between eight and nine pounds of essential oil of peppermint would be a fair average distillation from 16 cwts. of the dried herbs a corresponding bulk of lavender yielding, perhaps eleven or twelve pounds of essential oil. In such highly concentrated form, it does not take very many bottles to hold a thousand pounds' worth. In the sale of their manufactures, Messrs. J. & G. Miller come into contact neither with the public nor the retail trade, their buyers being the wholesale factors who supply the latter.

The Gentleman's Journal and Gentlewoman's Court Review, 16 May 1908

THE ARTS AT MERTON

Mr S. Weyland Kershaw, in a letter to the *Surrey Comet* for March 7th 1914, called attention to the visit of Queen Mary to Merton to see the splendid tapestry entitled 'The arming of the King', at that time being woven by hand at Morris works. We have also seen the allusion to this visit in the account of Merton Priory. Mr Herbert M. Ellis gives a brief but sympathetic sketch of the work in the Wimbledon and Merton Annual for 1904. William Morris, seeking a suitable site where he could realise his ideal of good workmanship, fixed upon certain old timber erections, put up by a Huguenot family early in the eighteenth century for silk-weaving on the very precincts of Merton Priory. Morris' underlying principle was that, as far as possible, all the work undertaken should be by hand, while the suitableness of Wandle water for dyeing was one of the inducements with him to select this particular site. Of the more notable fabrications of Morris' works were painted glass windows. Burne Jones, Morris' beloved college friend, entrusted his designs entirely to him and the work revived an art which

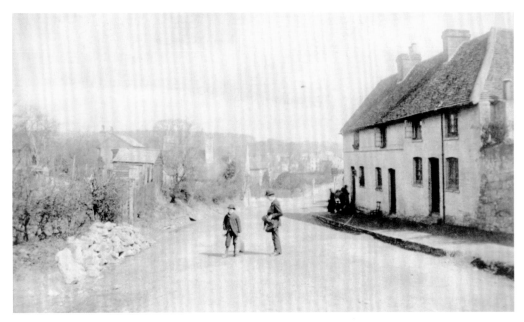

REDHILL

reached its former highest level in the fifteenth century. Mr Ellis, speaking of a Morris wiodow, has these words: 'It possesses a depth and soft brilliancy of colour, nobility of design and breadth of treatment for which you seek in vain among modern productions.' Another art nobly revived by Morris was Tapestry and Mr Ellis tells us how lie saw young men sitting on low stools working with many-hued silks at a great tapestry representing the 'Adoration of the Magi'. He gives a beautiful photograph of the tapestry. The figures have all the 'sad sincerity' characteristic of Burne-Jones paintings, but foreground, background, decoration and colouring are stated to be by William Morris. So vast was this work of art that, when completed it would extend across the whole east end of Eton College window. This article ends with a portrait of the noble head of this man of genius in the calm of death—drawn by Mr C. Fairfax-Murray and these words—'The new Arts he created and the old Arts he resuscitated at Merton will give our sad-faced Surrey village remembrances centuries after the place itself has become an indistinguishable portion of the London wilderness.' Mr Ellis, however, 'prophesied before he knew', for the Town-planning scheme of the Local Authority will of a surety prevent the ancient seat of Merton Abbey, beside the Wandle, from becoming lost in the 'wilderness'.

John Morrison Hobson

REDHILL

Redhill, like most other 'junctions', is a scattered, bewildering, unsatisfactory place. It lies sprawling vaguely over a large extent of ground, and after you have walked round and about it for an hour or so, you feel as if you were getting tied up in a hopeless knot with railroad lines. The town has no plan; the streets have grown up by accident, and all kinds of houses have been dropped down upon them at random. There is a good common on the outskirts, but even this is disfigured by large sand pits, which it is advisable to approach with caution. While standing up above one of them, I saw a large mass dislodge itself and come crashing to the ground. 'That's nothing', said a man who noticed my astonishment; 'I was up here the other day when eight or ten tons fell. Plenty of men have been killed down there.' There are some good views towards Reigate on the one side and Horley on the other, from a clump of trees in the middle of the common, and a stirring walk may be taken as far as Reigate. There are also some attractive specimens of Surrey lanes in the neighbourhood, deep and shady, covered with wild flowers in spring, and in the summer almost dark with the foliage of the trees above.

Louis Jennings

REIGATE HEATH MILL CHURCH

THE WINDMILL CHURCH

From the grim cluster of asylums, reformatories, and industrial schools at Redhill, one finds solace presently at Reigate, where houses of from sixteenth to late eighteenth century date abound. It is a town typical of the coaching age, to which it owed its eighteenth-century prosperity, and is built in characteristic red brick. Thence to Reigate Heath, on whose fine breezy expanse the curious may discover that prime curiosity, the 'Windmill Church'. The old windmill thus converted into a church nearly a quarter of a century ago has a curious history. Now a chapel-of-ease to Reigate, under the style of the 'Chapel of Holy Cross', the first service was conducted on the 14th of September 1880, and has been continued regularly on every Sunday since. The reason for this singular conversion was purely sentimental, the mill standing on the site of one of four ancient wayside oratories established for the use of pilgrims in days when this, the Pilgrims' road from Southampton to Winchester and Canterbury, was largely travelled.

One of the oratories became a prison, another suffered a transformation into a house attached to pleasure-grounds, and the Chapel of Holy Cross became a windmill. The original building built for worship and used for milling, has long disappeared, and the present one, built as a mill and now used as a church, took its place. No attempt has been made to alter the character of the interior, whose oddly timbered circular space is simply fitted with altar, rush-bottomed chairs, and cocoa-nut matting, the great beams painted and here and there stencilled with ecclesiastical designs. A rental of one shilling a year is paid for the use of the building to Lady Henry Somerset.

Charles G. Harper

COACHING DAYS

According to Shergold, Reigate in the old coaching days was the scene of the most romantic episodes imaginable. He is full of comparisons between the easy charm of conversation among riders by coach and the ungracious silences of travelling by rail and this is what you read about Reigate and the fare who travelled by coach:—

'There was an advantage and an interest in travelling by coach which travelling by rail can never communicate. In the former you saw men and their faces and acquired some information, in the latter you learn nothing except the number of persons killed or injured in the last accident. A young man who entered the coach at eight o'clock in

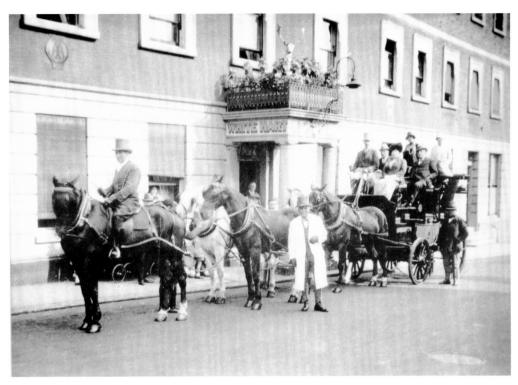

LAST OF THE COACHES, REIGATE

the morning at Brighton took his seat perhaps opposite a young lady whom he thought pretty and interesting. When he arrived at Cuckfield he began to be in love; at Crawley he was desperately smitten; at Reigate his passion became irretrievable and when he gave her his arm to ascend the steep ridges of Reigate Hill—a just emblem, by the way, of human life—he declared his passion, and they were married soon after. Nothing of this sort ever occurs on railroads. Sentiments never bloom on the iron soil of those sulky conveyances. A woman was a creature to be looked at, admired, courted, and beloved in a stage-coach; but on a railway a woman is nothing but a package, a bundle of goods committed to the care of the railway company's servants who take care of the poor thing as they would take care of any other bale of goods. It is said that matches are made in heaven; it may likewise be said that matches more often begin in the old stage-coaches, and that railroads are the antipodes of love.'

Eric Parker

REIGATE HILL

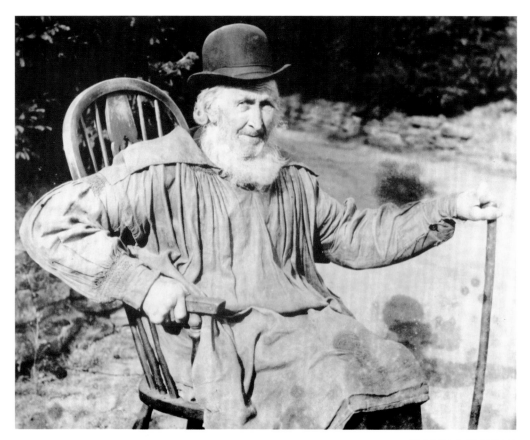

AN OLD LABOURER

THE OLD FARM-LABOURER

'Wiggie' was once the old manor-house of Redhill, and portions of its dismantled walls are still standing close to the new villa residence which belongs to Mr Trower and his brother. In this old-world garden, with its lichen-covered apple-trees, twisted by south-west winds into Corot-like shapes, one of the institutions to be found there up to a year ago was an old Surrey farm-labourer called 'Dan'll'. He was a fine specimen of our old peasant stock. He began working for Mr Trower's grandfather in the reign of William IV, at the age of nine, and died in harness after seventy-eight years of faithful service. His father served in the Peninsular War, and fought at the battle of Waterloo, and 'Dan'll' Gumbrill's direct descendants now number over a hundred and twenty.

So struck was the present King with 'Dan'll' that he wrote to Mr Trower asking for a photograph of the old farm-labourer, stating that it was 'very creditable both to Gumbrill and his employers that he should have remained so long in one situation'.

Mr Trower says that Dan'll worked for fifty years without asking for a rise in wages, and that the only occasion on which he was absent from duty was when he had "arf a day off to git married'. Poor old Dan'll evidently belonged to that old school of farm servant who was so unaccustomed to be relieved of toil for a single day that he resembled another old farm servant employed by the Trower family, who, having asked for a day's holiday, was found, to the surprise of his employer, to be still at work. When reasoned with, the old man replied: 'I couldn't stand it no longer, measter. I bain't used to that sort of thing, you know.'

The bicycle has, to a large extent, altered this kind of servitude in the younger generation of farm servants, and the motor bus will probably be the means of extending the very limited parochial horizon of the middle-aged labourer.

Mr Trower told me two amazing anecdotes of old Dan'll. Whilst Dan'll was performing his seventy-fifth year of haymaking at 'Wiggie', he was photographed by Press photographers, and one photograph found its way out to New Zealand, where it occupied the whole page of a weekly journal.

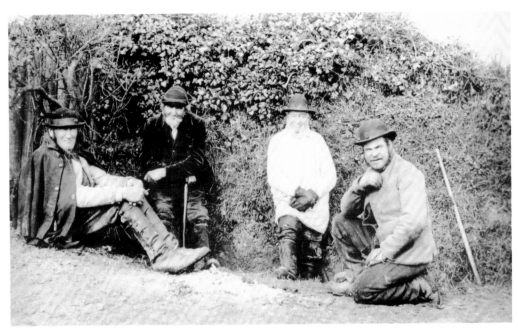

FARM LABOURERS

'Well, Dan'll,' said Mr Trower to him, as he worked among his daffydowndillies, 'have you seen your photograph?'

'Yees, sir,' answered Dan'll; 'my darter out in New Zealand sent me home my portograph, and I heerd tell that they've got it in Mericky. Then they be getting out papers there now, sir?'

One day Mr Trower said to him: 'Dan'll, my nephew is coming home from Australia, and is bringing home his Australian wife with him.'

Dan'll thought for a moment, and then remarked: 'Ah, I lay she will talk funny, she will.' He evidently imagined Mr Trower's nephew had married a member of the aborigines.

'Wiggie', has now an extensive rookery, built amongst the topmost branches of its high elms. Last year there were but five nests, and during the autumn a parliament was held, when hundreds of rooks assembled. Evidently colonisation there and then was decided upon, for the rooks could not apparently resist the site of an old-world garden over which broods a love of nature, where the gorse and bramble are welcomed as much as the daffodil and the primula, and this spring no fewer than fifty nests are to be counted in the tree-tops.

Seeds used to be sown in this old-world garden according to the dates of local fairs. Thus the time for planting scarlet runner beans was on the day of the Crawley Fair, and the time for sowing autumn cabbage was religiously kept to the 15th July, the date of the now extinct Blechingley Fair.

Weather changes, in the minds of these old tillers of the soil employed at 'Wiggie', were always attributed to the moon.

'I reckon we'll have a change afore very long, measter,' remarked one old weather-beaten prophet one Saturday night to Mr Trower's father.

'What makes you think so, Tom?' asked Mr Trower, senior.

'I doan't like the leuk o' the moon,' he replied. 'She's a-lyin' a deal too much on her back.'

These men who worked at 'Wiggie' belonged to that fast-dying class of farm servants who used to sing with gusto at the harvest supper the following song:

> Here's a health unto our measter,
> The founder of this feast,
> I pray to God with all my heart
> His soul in heaven may rest.

SOLDIER-BOY

That all his works may prasper,
Whate'er he takes in hand,
For we are all his sarvants,
And all at his command. . .

F. E. Green

LINGFIELD MACHINE-GUM DETACHMENT

SOLDIER COUNTRY

Half of north-west Surrey belongs to the soldiers. Chobham Common, Bagshot Heath, Chobham Ridges, Bisley, Pirbright, York Town, and Camberley contain among them pretty nearly all the camps, colleges, training grounds, and rifle-ranges that do not belong to Aldershot over the Hampshire border. The whole aspect of the country is

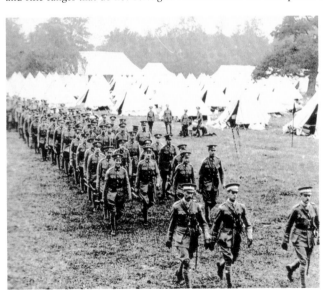

military; rural outlandishness has been drilled into rigidity and pattern. The roads run as straight as if the Romans had driven them—and, indeed, some of them in the neighbourhood are Roman roads; the face of the hills and heather commons is scored with roads like figures of Euclid, triangles, oblongs, radii, rhomboids, every kind of road which enables you to go from one place to another in the shortest space of time possible; which, for that matter, is a thing you frequently wish to do. Nobody wants to linger on a road as straight as a gunshot.

Eric Parker

CAMBRIDGE UNIVERSITY OTC, MYTCHETT

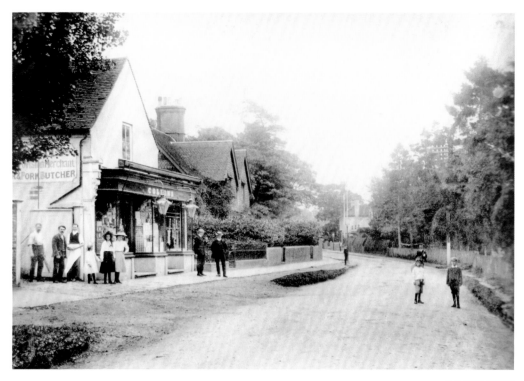

CRANLEIGH

LAMB TO THE SLAUGHTER

The Roman road, now hardly traceable, cuts the road from Cranleigh near Ewhurst. Ewhurst lives comfortably fifty years behind Cranleigh, and is still, happily, what the late Louis Jennings called it in *Field Paths and Green Lanes*, 'a one-horse place'. When Mr Jennings was at Ewhurst everybody was half-asleep. 'At the post-office a woman and a girl turned out in some consternation to look at me, thinking, perhaps, that I had a letter concealed about me, and was about to post it, and thus overwhelm them with work.' Such a village would be desirable anywhere. But Ewhurst, although it can be sleepy in the sunshine, as everything in the country ought to be, has an eye for country business. At the door of the post-office, when I was there on a hot day in July, a long-tailed sheep, fat and woolly, cropped the grass. It was a pet lamb grown up, apparently, and pleased to be patted. A cart drove up and there was a conversation which might have come out of *Edgeworth's Parent's Assistant* when Simple Susan's pet lamb was in the same evil case. From the cart descended a butcher, who shook his head when questioned by the lamb's caretaker, or keeper, who looked after its owner's interests from a neighbouring dwelling. Wasn't he worth three pounds? Not three pounds; no. Fifty-five shillings, perhaps, would be a fair price in a week's time. A fair price in a week's time—it was impossible to listen to the careful bargaining over the creature feeding in the sun. I went into the shop to buy something, and within a few minutes was asked, as an obvious admirer of the lamb, whether I would like him for fifty shillings.

Miss Edgeworth should have stayed at Ewhurst, and have seen the best of an English village as I did that July afternoon. Opposite the church—a church which, with its stainless glass windows, its white walls, and its green carpet and curtains, gives you the feeling of entering a drawing-room—are the village schools. Out of the schools as I watched them the village children came tumbling. Half of them made for a passage by the churchyard, where a small boy, gipsy or pedlar's child, sat in the shadow of the wall. He was dusty and hot, and by him lay a large bundle wrapped in a spotted blue handkerchief. One of the schoolchildren stopped after passing him, and whispered to another. Then four little boys went back and each dropped a penny or a half-penny into the child's hand. Then they ran off through the churchyard.

Eric Parker

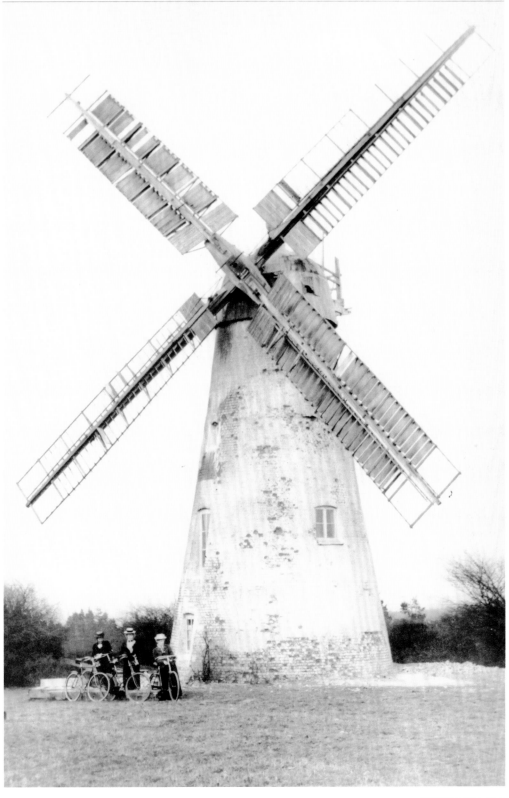

EWHURST MILL

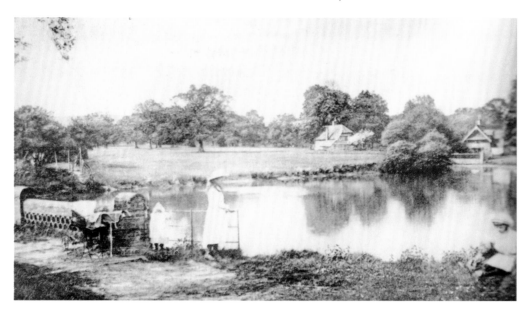

OCKLEY

SMUGGLERS' COUNTRY

Although so quiet a little village to-day, the neighbourhood of Ockley has seen some wild doings. Holmbury Hill, to the north, was once one of the principal settlements of the 'Heathers', or broom squires, who still survive, a more respectable and a weaker folk, under Hindhead and elsewhere. Here one of their chief occupations was smuggling; indeed, the range of hills round Ewhurst and Holmbury Common served as a kind of halfway house for the gentlemen who were riding with silk and brandy from the Sussex seaboard to London. It was a Bunwash mother who used to put her child to bed with the injunction, 'Now, mind, if the gentlement come along, don't you look out of the window'; doubtless the text which inspired Mr Kipling's delightful verses. But there must have been many a Ewhurst and Ockley mother who knew 'the gentlemen' by sight, and counselled confiding children to hold their tongues and look in the proper direction as the Burwash woman bids her child in Mr Kipling's song:

If you meet King George's men, dressed in blue and red,
You be careful what you say, and mindful what is said.
If they call you 'pretty maid', and chuck you 'neath the chin,
Don't you tell where no one is, not yet where no one's been
If you do as you've been told, likely there's a chance,
You'll be give a dainty doll, all the way from France,
With a cap of Valenciennes, and a velvet hood—
A present from the Gentlemen, along o' being good!
 Five and twenty ponies
 Trotting through the dark—
 Brandy for the Parson,
 'Baccy for the Clerk,
Them that asks no questions isn't told a lie !
Watch the wall, my darling, while the Gentlemen go by!

The memory of smuggling under Leith Hill has, indeed, lasted into the last decade. Mr H.E. Malden, the Surrey historian to whom all Surrey writers and readers owe so much, tells us in a paper on Holmbury Hill and its neighbourhood that he personally knew an old man, a native of Coldharbour, who had actually seen the game going on. He was born, it is true, in 1802, but he lived to be a hundred years old, and to talk to Mr Malden discreetly about what he had seen. In his conversation Mr Malden remarks with proper tranquillity 'he indicated

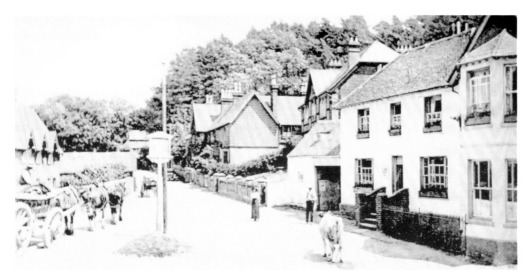

COLDHARBOUR

this and that respectable neighbour. Well, he said, his grandfather, and *his* grandfather and so on, knew something about the smuggling. He, of course, had done nothing in that way, but he remembered his father holding open the gate at the end of Crocker's Lane, Coldharbour, for a body of men on horseback, each with a keg of brandy behind him, to ride through. A man with whom he had worked told him how he was witness of a scene when a bold gatekeeper refused to open his turnpike gate to a body of armed men on horseback, who, after threatening hiin in vain, turned aside across the fields'. Relics of the past still remain in the district. Under Holmbury Hill there is a cottage of which the cellars run right back into the hill; tradition has placed kegs of brandy in them. A naval cutlass was picked up some thirty years ago in a field by Leith Hill—possibly it was used in a smugglers' fray with King George's men. Nor was it long ago that a trackway which runs from Forest Green, two miles to the west of Ockley, through Tanhurst over Leith Hill, was known as the Smuggler's Way.

Eric Parker

ON LEITH HILL

The two industries of Leith Hill are gathering whortleberries and putting out heath fires. The latter is a very solemn performance—at least, so it seemed to me when I came upon a group of men sitting round a barrel of beer and discussing ways and means. The barrel of beer had to be set up first in a cool place, like a woodland altar, before the men attempted to beat out the fire.

The summit of Leith Hill from Coldharbour is made quickest on foot over the heather-crowned moor, though the carriage drive which brings you to the steps of the hotel is one which every lover of trees should not fail to take. The drive is through an avenue of trees which would have delighted the author of *Silva*, whose descendant is still lord of this manor, though the avenue belongs, I believe, to Sir Alexander Hargreaves Browne, the owner of Broome Hall, the lake of which glitters like a drop of summer sky held captive by green hills.

Nearly every conceivable variety of tree that will take root in English soil has been planted in this avenue, and there is one which never fails to prick me with gentle excitation, and this is a kind of spruce fir, which has a foliage as blue as the English Channel when white cumulus clouds sail over it in summer.

At the foot of the sharp shoulder of the hill crowned by the tower stands the modern Surrey Trust Inn, where breakfast is served in the early hours of the morning to the youthful who make the adventure from distant towns to see the sun rise from the highest point of Surrey. It certainly requires youthful legs to make the scramble up the slippery footpath that scars the brow of the hill-summit. Ponderous middle-age can walk up the deep sandy lane on the right, under the shade of the pines.

Once I climbed the hill to greet the dawn, but my early devotion at the altar of Pan was rudely broken into

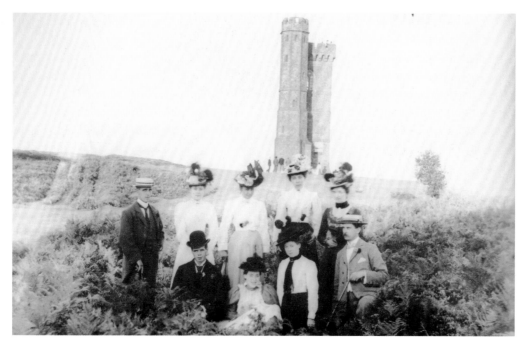

LEITH HILL TOWER

by a cycling party resonant with cockneydom. I had started from my home at eleven o'clock, and, after resting for an hour on the banks of Anstiebury Camp, I made my final climb to the summit. On the bare crown of the hill, around which usually a strong wind is blowing, the earth this morning seemed to be holding its breath, so still and silent was it, as I watched the silver streak of light tiptoeing over the tops of the larches, firing them into lance-heads. I held my breath too, as I rose from the short down grass. Then suddenly these words broke upon my ears: 'What O, 'Erry! ain't this a bloomin' knockout?' and about thirty jolly, panting, perspiring cyclists pushed their bikes up to the summit, invoking the gods of great cities as they threw themselves on the ground. The air suddenly lost its virgin purity, and a streak of red stained the sky. Still, I was glad these young fellows had accomplished their job, and had made an effort to slough off the mire of the city. I descended the hill, and slept soundly under a hedge until I was wakened by a shepherd.

F.E. Green

A WORTHWHILE CLIMB

I have never been on Leith Hill on the day of days, nor seen the spires of forty-one churches in London, which the Ordnance Surveyors counted in 1844, nor watched a sail on the sea through Shoreham Gap. But I was once there on an August day of sunshine and cold rain and wind, and saw all the southern view in a way I should like to see it again. I came to the hill from the west by Coldharbour, and black rain brooded over all the distance to the east. To the south-east the air was clear to the Kent horizon; north-east the glass of the Crystal Palace winked in the sun. Then the rain came down over the weald to the south and the west, and the cloud rode over the fields and dotted trees like the shower of rain in Struwelpeter, blotting out the villages and the Sussex downs one by one. Then behind the cloud drove up blank blue air, and to the west Hindhead and Blackdown and hills beyond them came clean cut in a cold wind that made my eyes water; Hascombe Hill stood up dark and far, and the Hog's Back to the north of it, edged like grey paper; I was lucky to see the Hog's Back so plainly, the vendor of tea and melons at the tower told me; she had seen the sea by Shoreham Gap that morning, but often went a week without seeing the Hog's Back. Below, to the south-west, Vachery Pond lay a gold mirror; Chanctonbury Ring faithfully marked the south as the rain drew past, and I left Leith Hill with the rain cloud riding down wind like night over the weald of Kent.

Eric Parker

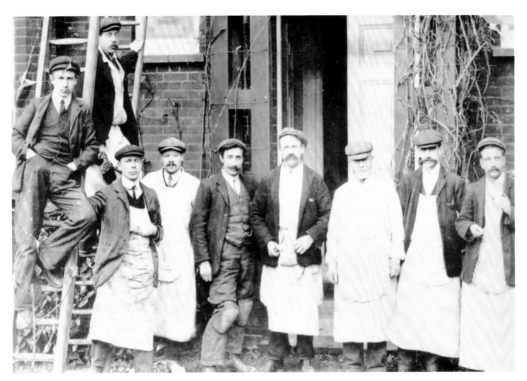

WORKING CLOTHES

SHABBINESS

Now, alas! all workpeople, except those who do the hardest outdoor labour, such as navvies, stone-pitmen, and farm-labourers, are clothed in a dead-level of shabbiness. The shops are full of cheap suits with a pretence of fashion, which are bought for Sunday wear. They are soon past their best, and are then taken into working use, for which they are entirely unfit. The result is that it is only the farm-labourers and his hardworking kind who *must* wear the right or suitable kind of clothes, who look well dressed. For real working-clothes, like all other things that are right and fit for their purpose, *never look shabby*. They may be soil-stained; they may be well-worn, but they never have that sordid, shameful, degraded appearance of the shoddy modern Sunday suit put to an inappropriate use.

Gertrude Jekyll

CHEERFULNESS

A great charm among our older people was their pleasant, cheerful manner. Here and there, of course, there was some one of a dull or surly nature, but such a thing was quite exceptional. Sometimes this love of cheerfulness extended even beyond the grave, as in the case of an old bell-ringer, who left five pounds to be spent among his fellow-ringers when he died. They were to ring a merry peal at his funeral and have a grand supper. 'No muffled bells for me', he said.

It is painful to see how many of the faces of quite young children, as well as those of grown-up people, habitually wear a scowl or some other displeasing or disfiguring expression; whereas the rule was among the old people I remember, and the few of them that remain, as well as among the present-day labouring people who live in the remoter places, and have inherited their ancestors' graces of manner and countenance; that they met each other with a frank, free bearing and a ready smile, as if they unconsciously carried in their minds the fine old bell-ringer's testamentary injunction: 'No muffled bells for me'.

Gertrude Jekyll

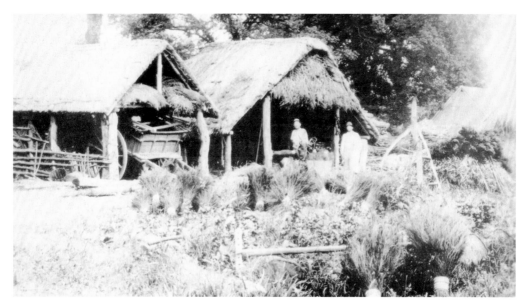

THE BROOM FACTORY

BROOM SQUIRES

A cottage industry that still survives in this neighbourhood is the making of birch and heath brooms. As no cast-iron or machine-made substitute for these useful things has yet appeared, let us hope that they may still remain. Their safety is probably in their cheapness for the price in the country, buying direct from the maker, is three and sixpence a dozen for birch and half-a-crown a dozen for heath. The materials cost the makers very little; often much less than the rightful owner of the birches and handle stuff intends or is aware of, and they are quickly and easily made.

The birch spray is not used fresh. It is put aside to dry and toughen for some months. Then they 'break birch for brooms'. A faggot is opened, and the spray is broken by hand to the right size and laid in bundles. Breaking birch is often women's work. The 'bonds' that fasten the spray on to the handle are of hazel or withy, split and shaved with the knife into thick ribbons. They are soaked in water to make them lissom. There is usually a little pool of water near the broommaker's shed, where the bonds are soaked.

The broom-squarer gathers up the spray round the end of the stick, sitting in front of a heavy fixed block to which the further end of a bond is made fast. He pushes the near end of the bond into the butts of the spray, nearly at a right angle to the binding. He then binds by rolling the broom away from him, pulling it tight as it goes. When he has wound up to the length of the bond the end is released and pushed into the work. Heath brooms have two bonds; birch, which are much longer, have three. A hole is bored between the strands of spray and through the stick, and a peg is driven tightly through, so that the spray cannot slip off the stick. The rough butts are then trimmed off, and the broom is complete.

They generally work in thatched sheds, the thatch commonly of heather. In old days it was usual to keep their money in some hole in the thatch inside; they considered it safer than keeping it in the cottages. The man would put up his hand into a place something like a bird's nest, and there was the money. An old friend, who knew their ways well, told me he had known of a sum of between three and four hundred pounds being kept in this way.

Gertrude Jekyll

HARBOURING A GRUDGE

Mr Baring Gould in his description of broom squires of the latter end of a hundred years ago, does not paint a single one with a redeeming feature. Possibly their characters might have become less dour if they had not lived tied by the leg, as it were, imbedded in the lees of the Devil's Punch Bowl. As squatters they became freeholders, and

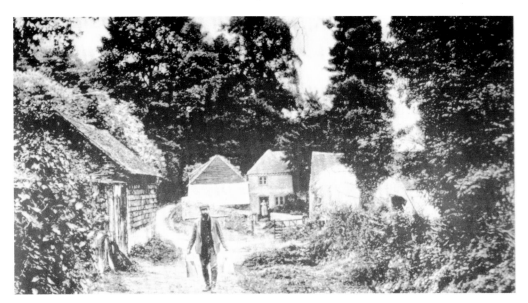

BROOM SQUIRE'S COTTAGE, DEVIL'S PUNCH BOWL

as freeholders their lives seem to have been given up to sordid acquisitiveness, and were destitute of the charm and good-fellowship of the Borrovian gipsies. But, whatever the broom squires were a hundred years ago, the broom squire of to-day is a person with whom one has a certain amount of sympathy. (One of these, who lives in one of the Hindhead Bottoms, has sat to a number of artists, owing to his extraordinary likeness to the conventional Jesus Christ.) In days gone by, the graceful silver birch with its purple top was his for the cutting. With the stouter stems he made the handles of his brooms. The heather which formed the brush of the brooms was his, and these sold in wagon-loads in county towns. The fern, too, was his for the cutting: it bedded his pig, his pony, and his cow; and

there was a certain amount of grazing to be obtained free of charge where young gorse and grass grew, unchallenged by the encroaching bracken.

Now a National Trust holds sway over his domain, or a lord of the manor, each of whom extracts a price for the heather, and the cutting of the birch is prohibited. Strange as it may sound, sporting rights are let by the National Trust, and game is strictly guarded by keepers. Quite recently heath fires used to break out fairly frequently, for the 'fern' was denied to certain cottagers, who imagined they still possessed the right to cut.

'How do you account for this?' said a member of the National Trust Committee to a broom squire. 'Do you know who does it?'

'You've too mighty particular nowadays, that's what's the matter, and some folk may be angry with you. Why is it that no man keeps a pig round about the moor nowadays? If he does, he has to go down to the corn merchant in Haslemere and pay eighteen-pence for a truss of straw. He used to be able to cut a bit of dried farn for nothing.'

This is how a broom squire put it when I sought

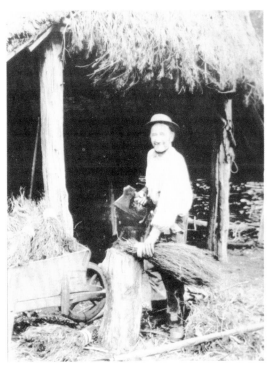

TRIMMING THE SPRAY

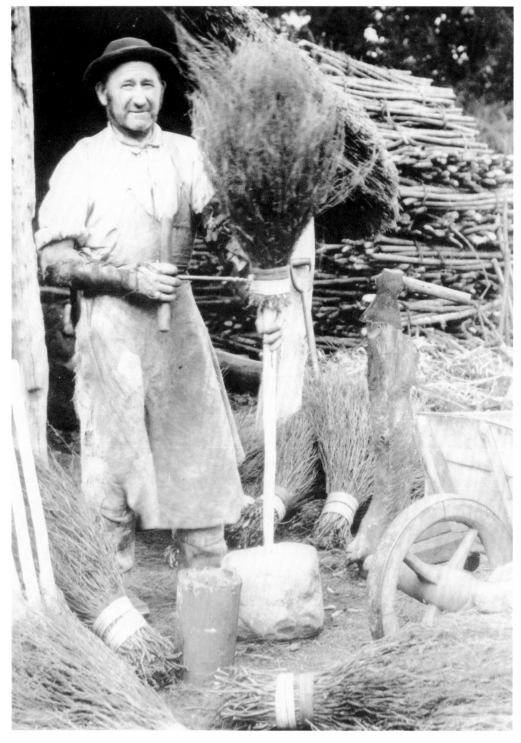

FINISHING A BROOM

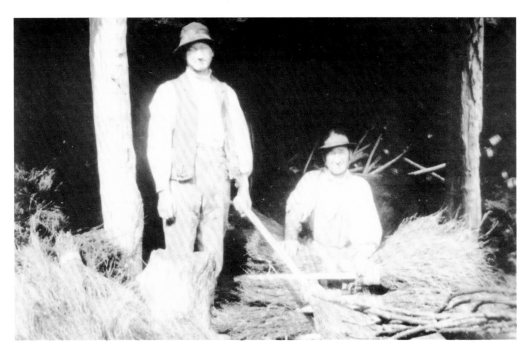

BROOM PACKERS

shelter in his hut during a downpour of rain. He was making brooms, the materials for which had to be obtained miles away on Lord Leconfield's property.

'I have orders', he told me, 'right away as far as Dorking, for forty-two dozen brooms, which I shall not be able to supply.'

The making of brooms seems to be still a thriving rural industry, when most articles of this description are supplied by factories.

Enclosure Acts had gone hard with the cottagers, for most of this wild moorland country, practically the whole of Hindhead parish, was common land before the Enclosure Acts. The folk who have made money out of the Enclosure Acts are a few great landlords and some Haslernere tradesmen, who, after Tyndall's unpremeditated boom, sent possible building sites 'skyrocketting', as the Americans say. Mr A. J. Balfour was at one time one of these fortunate owners. A local tradesman reaped a fortune by buying land in the early days of the boom. The cottager and the broom squire, however, have been left out in the cold.

My Lord of the Besom went on to speak of gamekeepers, of whom he had no good word to say.

'They were a bad lot,' he declared. 'I've seen them lay out on the moor on moonlight nights where the paths meet, and shoot a hare as it runs towards them. You can see a hare clearly coming over the moor on a moonlight night.'

Against one keeper in particular he harboured a grudge. By permission of the gentleman who had taken the shooting, the broom squire had set a trap in his own garden for the rabbits that overran his cabbage plot. This keeper not only appropriated the rabbits in the snare when caught, but the snare as well, and laughed at the broom squire for the futility of his craft.

'"I shall always keep £1 in my pocket", I said to a mate, "so that, if I meet Bill Black in a pub, I shall be able to give him a punch on the head."' This expensive luxury was, however, denied him, for the statement had been passed on to the keeper by some kind friend, and the keeper left hurriedly every public-house into which the broom squire entered. 'But one day', continued the broom squire, tying a withe round a besom, 'I got as far as Twickenham with a load of brooms. My uncle and my son were with me, and, it being a very hot day, we all went to sleep inside a pub there. Suddenly my uncle whispers in my ear, "Jim, here's Bill Black." I wakes up and swears, and thinks the time has really come when I could spend my quid with the greatest pleasure. But before I could so much as tread on his corns without axing his pardon, he was off out of the bar and down the street.'

F. E. Green

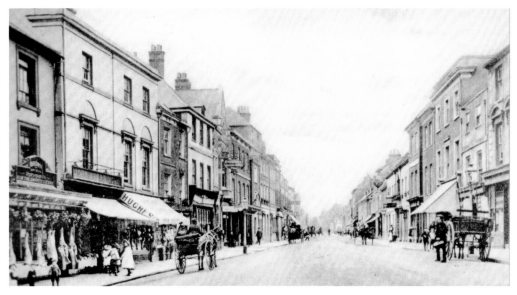

WEST STREET, FARNHAM

FARNHAM FAIR

As the day wore on and the cattle and sheep and horses disappeared, Castle Street filled up more and more with 'shows' and lounging villagers bent on pleasure. I think the 'cokernut-shy' had not quite ousted the more ancient Aunt Sally; certainly not wooden balls but thick sticks about eighteen inches long were the missiles. They were usually thrown whirling from one end, but one clever man tossed his sticks level from the middle and won too many 'cokernuts'. There was a rich selection of fat ladies, bearded ladies, abortions of all sorts. Some of the shows were fronted with platforms with steps up to them, where mountebanks could address the public—'Walk up! Walk up! Ladies and Gentlemen,' or musicians could deafen them with trumpet and drum; and many 'shows' were alluring with gaudy paintings on the outside.—Royal Bengal Tigers, Kings, Slaves—I cannot recall what. For I went into none of these shows though I would have liked to go. Not once could any of the seniors with me be persuaded to venture on such a treat.

But two or three minor shows I did get into; and I can still conjure up a recollection of grey-looking damp-looking canvas for their tents. In one of them you did but walk round, putting one eye to a hole, through which a view could be seen. It was a dismal show—as cheerful as squinting into a tiny microscope let into the end of a penholder and seeing perhaps Windsor Castle or The Crystal Palace—a wonder we sometimes failed to wonder at. In dill, gloomy 'peep-show' of Farnham Fair might be seen 'The Relief of Lucklow', or 'The Coronation Of Queen Victoria' or some other equally exciting spectacle. There were but nine or ten peep-holes in all; and, I think, but three or four disillusioned patrons solemnly going round besides myself, to hide the spaces of weather-beaten tent; so that one felt very forlorn within and quite glad to come out. But in another tent, where the proprietors appreciated a little better the value of excitement, a crowd of men and women seated on wooden forms watched performing canaries. The canaries were hauling tiny buckets up tiny windlasses—doing all sorts of useless and interesting things, the exhibitor of them being a conjuror. Can it have been the same mail, I wonder, in the same dingy little tent, who worked a certain well-remembered miracle before my very eyes? I see at any rate, in a certain little suffocating tent about the colour of slate-pencil, a huddle of people so close together as to be almost on top of one another, watching tricks at a table. The people were in smock frocks—I was wedged in amongst them; and how the man at the table borrowed a chimneypot hat from amongst the audience, and made a pudding in it, has already been told. My memory of the occasion dies clean away after the distribution of the pudding. I don't know what became of the hat. It was probably given back unhurt to its owner.

In the late afternoon it became possible to buy little penny squirts—forerunners of 'ladies' tormentors'; though hardly so far off may one date the cry 'All the fun of the fair!' Late in the afternoon too, while the throngs of people

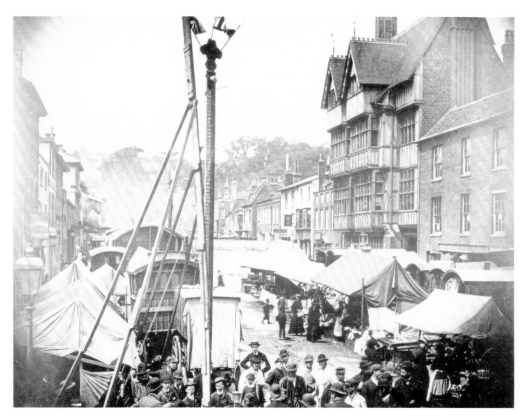

FARNHAM FAIR

thickened, the roundabouts began to be busy. I never rode on one. In fact, about tea-time I seem to have forsaken the Fair and gone home; for no memory remains of any evening there. Once, a chimney afire at home raised a cry in the Fair that Sturt's newspaper shop was afire, and brought hopeful people crowding to see, occasionally a loud bang told where some wag had thrown a squib down into the crowd. But this I never saw. And if I saw, I nowise remember, any of my father's cronies or customers, any farmer friends, dropping in for a smoke on Fair Day evening, as doubtless they did. Doubtless too I had myself been packed off to bed betimes. The next morning, unless for filth I didn't see, or possibly piles of hurdles from the dismantled pens I didn't notice, nothing was left of the Fair but a smell, mostly of sheep, that clung to the ancient street for a few hours. The quiet of the centuries was recovered. From aloft the Castle looked down as it had done in all my memory, upon a very peaceful town.

George Sturt

AN AFTERNOON OUT OF SCHOOL

I had a little white gathering on one finger—a thing to be proud of in itself, and the finger had to be poulticed with a bread poultice and afterwards bound up with rags into a 'dolly'. It was not really bad; but it gave good excuse for staying away from school that afternoon. And then—who so gratified as I?—my mother put on her walking things and took me with her on some unknown errand of her own—perhaps to find some sick newspaper boy or maidservant. Whatever the errand, it got a sort of afternoon calm into it; perhaps because it was an unwonted thing for my mother to be out walking at all, but likelier because of her own habitual manner.

Our way took us across Farnham, down Downing Street, and round two corners to Longbridge. There the Wey—'The River' as it is still called—widens out into a ford while the street crosses it in a bridge; and there we stopped. For there down by the ford, a boy was trying to drown a half-grown cat. We saw him throw the thing into the water, then saw it swim back to the river-bank, only to be picked up and thrown in again. But after we had watched this performance two or three times my Mother could bear it no longer. She explained to the boy how to

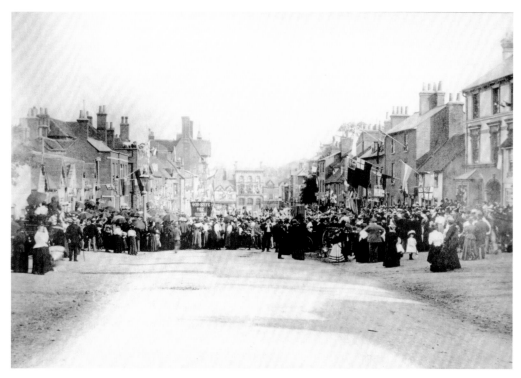

QUEEN VICTORIA'S GOLDEN JUBILEE CELEBRATIONS, FARNHAM

do his job quickly and therefore mercifully. He was to put the cat into a pail half full of water and then inserting another pail hold the cat down into the water until it was dead, which would not be more than a minute or two. I suppose then we hurried away, for I remember no more at all. Many years afterwards, acting on my mother's advice to that boy, I was able myself to destroy a pet that had to be killed; so I know it was good advice. But was it taken that afternoon? I am recalling only that it was not uncommon at that period to see a drowned cat or dog in 'The River'. The town drainage was not to come for many years. In this particular case I do not know what happened; or whether my mother and I went farther; or if anything more was done about the gathering on my finger. My memory is a complete blank as to the whole expedition. But at least I had a half holiday from school, and thought a gathering on my finger rather an important thing and did not disapprove of wearing a bread poultice.

George Sturt

THE FARNHAM 'HOPPERS'

A spectacle in itself for an hour or two in the autumn evening—from before sunset until dark—was this piece-meal home-going of the Farnham 'hoppers'. Not that they went, all of them, home every night. There were many gangs of 'outpickers' families from far away villages, or from the slums of Reading or of West London; and these came to stay until the hopping was over. Certainly it was one of the sights of the town to see some waggon-load of village folk arriving; or weeks later, to see the families going off again in their waggons, close packed; to see, to hear them; for especially on the return journey (glad to be sitting down again and going home) the villagers wedged into their waggons would be singing all along the streets—probably having money in their pockets, or wearing new clothes, or new boots bought in Farnham town. The slum dwellers too had no home to go to. They had but 'barricks'—mere shelters with absolutely no sanitary conveniences; while many 'gyppoes'—many of 'the royal family'—had pitched their tents in the same hop-grounds where they worked all day. But besides all these there were hundreds from the villages near Farnham—fathers, mothers, children, and all—hundreds who had locked up their cottages and trudged in out of the country for the day's work, wet or fine; who every nightfall trudged back again their mile or two, tired, dirty, hungry.

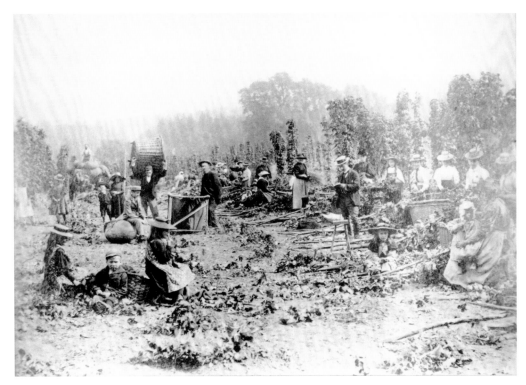

HOP PICKERS, FARNHAM

I was not aware, then, that anybody saw anything sorrowful in these endless streams of shabby-looking people along all the country lanes at nightfall—the women pushing perambulators, the children too often squalling, many a boy or girl dragging a piece of 'spile'—a broken hop-pole—perhaps for cooking a supper. But after many years I did hear men like Bettesworth (as I never at any time heard their 'betters') speak compassionately of the women's weary days. Truly it must have been weary work for many a cottage woman (though I have no doubt many husbands helped), seeing that in the cottages, reached at last, the beds wanted making, while there was some washing up to be done, no water without going to the well, no tap, no fire or gas. But these things I did not know; and I never thought of the hoppers' home-going as anything but jolly. After a day amongst hops, and out of doors, they were sure to sleep well; and they would not only be hungry; they would have plenty of relishing food. There was no doubt about that. If a 'hopping morning' was one sign of the season, so, no less surely, was the smell every night of herrings frying! 'Red herrings' ('Sojers') were the meal everywhere. Every street or lane rejoiced in the crisp appetising smell of their cooking. The night air was fragrant with it.

Another scent, that hung about the whole neighbourhood (obviously coming from a bluish vapour that poured thick from the kilns now and then)—a strong suffocating smell, came from the brimstone burnt with the drying hops. Though it made folk cough and was choking to asthmatic wind-pipes, all Farnham stoutly held that this brimstone burning was good for the town; fumigating it wholesomely with sulphur fumes when all those dirty out-pickers might be bringing in fearful infections from their slums. While I could still stand this smell (in after years I could not enter a kiln where hops were drying—it set me wheezing at once) I liked to see the golden drops that rained down from brimstone thrown on to the charcoal fire; better still I liked the potatoes which could be baked (in their jackets of course) in the ashes under the glowing grates. The only necessary ingredient was salt, which you took with you screwed up in a bit of newspaper. Plates and knives and forks were not needed, no one ever missed them.

The pay for picking was from three-halfpence to fourpence a bushel, according as the crop hung thick on the poles or needed finding, one hop at a time, under the leaves. A tedious job it always seemed to me: I never, at one sitting, exceeded a third of a bushel. In picking, the golden pollen from the hop flowers made one's fingers

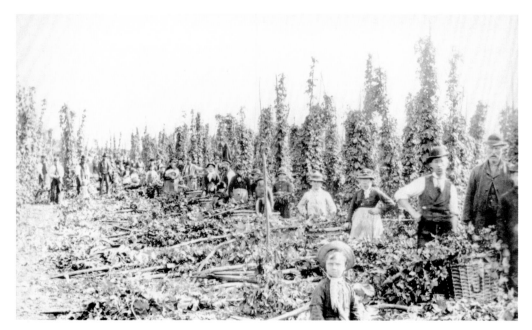

BADSHOT LEA

slightly sticky; while the Juice stained theln black; and (you found it when you went to wash) the leaves stung the skin. In the usual absence of pumice-stone I found the rough stone edge of the sink would rub off the worst of the stain; but nothing prevented my hands from smarting—no mottled soap or anything—when I dipped them into the cold water in the hand-bowl. While picking one would sometimes find amongst the hops a 'lion'—the larva of a lady-bird—and this lion was viewed with favour, as the alleged devourer of 'green fly'. Once or twice also I found amongst the leaves a 'hop-dog'—the huge green caterpillar of, I am told, the hawk moth.

Not only was the picking poorly paid; quite often the picker worked for a day or so actually without knowing what the rate of pay was to be! What could helpless women and children do otherwise than take the best they could get? Only, sometimes a grower over-reached himself, for after all, his crop could not wait for ever, and he ran serious risk, if he failed to make people willing to gather it for him. And they knew it. So my memory holds a dim picture of a 'strike'—an old dingy and mean street, a grey morning, and a little gang of people, shabby and with no order, straggling along the street, on their way to the house or shop of the stingy grower. I think they carried tin cans and other instruments of 'rough-music'. I think too they took for emblems of discontent a black flag, and a penny loaf on the top of a hop-pole, and a red-herring or 'sojer'. Yet this sort of thing after all was an exception. In another memory I see twilight falling on the long street of Farnham, where (in these old days) there is no wheel traffic unless, now and then, a load of 'sarplices' is being carried to a kiln; and the street is thronged—it is Saturday evening—with hoppers loafing from shop to shop, from public-house to public-house. They are sauntering, good-tempered, careless, shabby; one threads in and out through a street full of them.

In yet another memory I am, myself, in my grand-father's kitchen (by dim candle-light) while somebody bustles in and out of the pantry to draw beer and carry it into the adjoining sitting-room. For there nry grandfather is 'paying-off' hoppers. The old man (I must have peeped in at him) is at his usual table, looking very alert and capable; and perhaps he needed to be severe, for in the kitchen, besides the tallow candle, my aunt (or my elder sister perhaps) speaks of some 'dreadful' man there—who may be seen, in another peep, to stand black-avised, scratching, furtive, unwashed, opposite my grandfather. But all is well where my grandfather is.

When the picking was over the hop-growers had by no means done. First they had to market their crop, and then to start again, getting their hop-ground cleared up and ready for another year.

George Sturt

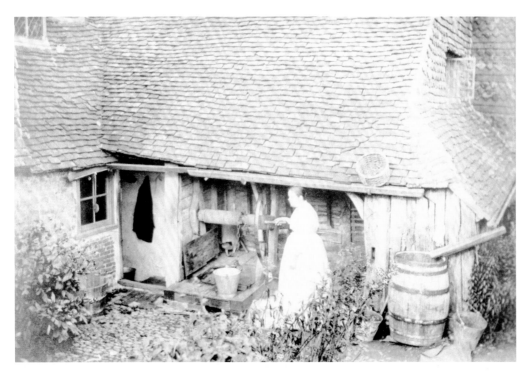

HASLEMERE

REMINISCENCES

June 1, 1904—A cool thundery rain this first of June drove Bettesworth to shelter. As usual at such times, he busied himself at sawing and splitting wood for kindling fires.

At the moment of my joining him he was breaking up an old wooden bucket which had lately been condemned as useless. 'Th' old bucket's done for', he said contemplatively. 'I dessay he seen a good deal o' brewin'; but there en't much of it done now. A good many men used to make purry near a livin' goin' round brewin' for people. Brown's in Church Street used to be a rare place for 'em. Dessay you knows there's a big yard there; an' then they had some good tackle, and plenty o' room for firin'. Pearsons, Coopers'—he named several who were wont to make use of Brown's yard and tackle. I asked, 'Did the cottage people brew?' But Bettesworth shook his head. 'I never knowed none much—only this sugar beer.'

'But they grew hops?' I asked.

'Oh yes,' Bettesworth assented, 'every garden had a few hills o' hops. But 't wa'n't very often they brewed any malted beer. Now 'n again one 'd get a peck o' malt, but gen'ly 'twas this sugar beer. Or else I've brewed over here at my old motherin-law's, 'cause they had the tackle, ye see; and so I have gone over there when I've killed a pig, to salt 'n.'

A suggestion that he would hardly know how to brew now caused him to smile. 'No, I don't s'pose I should' he admitted.

I urged next that nearly all people, I supposed, used at one time to brew their own beer. To which Bettesworth:

'And so they did bake their own bread. They'd buy some flour. . .'

I interrupted, remembering how he had himself grown corn, to ask if that was not rather the custom.

'Sometimes. Yes, I *have* growed corn as high as my own head, up there at the back of this cot. . . But my old gal and me, when hoppin' was over, we'd buy some flour, enough to last us through the winter, and then with some taters, and a pig salted down, I'd say, "There, we no call to *starve*, let the winter be *what* it will". Well, taters, ye see, didn't cost nothin'; and then we always had a pig. You couldn't pass a cottage at that time that hadn't a pigsty.... And there was milk, and butter, and bread. . .'

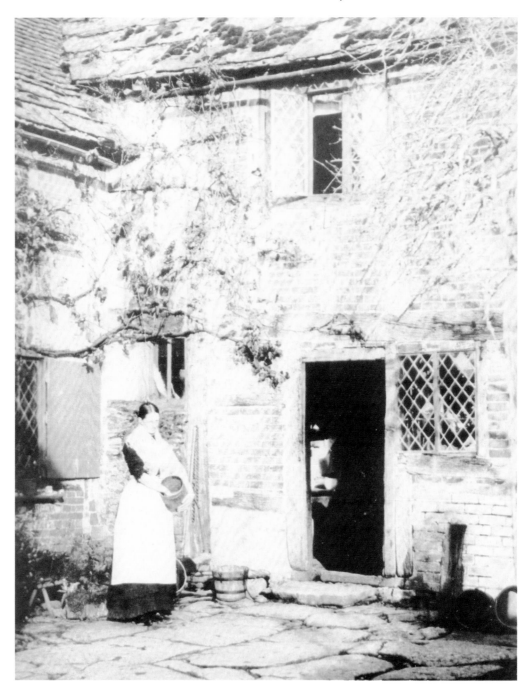

DAIRY YARD, UNSTEAD FARM

'But not many comforts?' I queried.

'No, 'twas rough. But I dunno—they used to look as strong an' jolly as they do now. But 'twas poor money. The first farm-house I went to I never had but thirty shillin's and my grub.'

'Thirty shillings in how long?'

'Twal'month. And I had to pay my washin' an' buy my own clothes out o' that:

The point was interesting. Did he buy his clothes at a shop, ready made?

'Yes. That was always same as 'tis now. Well, there was these round frocks—you'd get *they*'—home-made, he

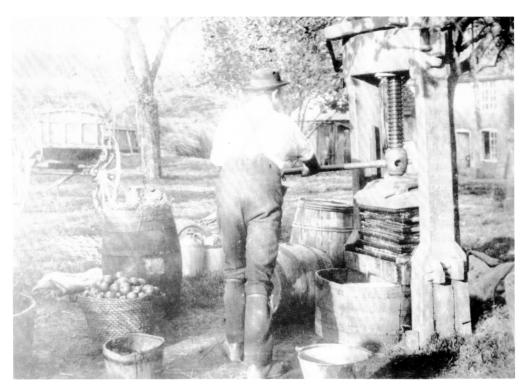

A CIDER PRESS

meant. And he told how his sister-in-law, Mrs Loveland, and her mother ,used to earn half a living' at making these 'round' or smock frocks to order, for neighbours. The stuff was bought: the price for making it up was eighteen-pence, 'or if you had much work on 'em, two shillin's'.

Much fancy-work, did he mean?

'The gaugin's, you knew, about here: Bettesworth spread his hands over his chest, and continued, 'Most men got 'em made; their wives 'd make 'em. Some women, o' course, if they wasn't handy wi' the needle, 'd git somebody else to do 'em. They was warmer 'n anybody 'd think. And if you bought brown stuff, 'tis surprisin' what a lot o' rain they'd keep out. One o' them, and a woollen jacket under it, and them yello' leather gaiters right up your thighs—you could go out in the rain. . . But 'twas a white round frock for Sundays.'

George Sturt

CIDER-MAKING

Cider is still made with the old wooden press. The apples are first crushed by a roller in the cider-mill. Two men work it together by a handle on each side, while one of them presses the stream of apples down towards the roller. The crushed pulp falls into a tub, and is then put into coarse fibr~ bags. These are then packed one over the other in the press with boards between. The heavy presser is screwed down on to the bags of pulp till they are quite flattened, and all the juice that can be squeezed out of them has come away.

The heaps of apples, mostly of the poorest of the orchard produce, do not look at all inviting. Many are muddy and bruised, but in they go, mud and all; and when a mug of the freshly-pressed juice is offered, and is accepted with some internal hesitation, whose outward expression is repressed for civility's sake, one is pleasantly surprised to find what a delicious drink, tasting clean and pure and refreshing, is this newly-drawn juice of quite second and third-rate apples. For though cider of a kind is frequently made, it is by no means a cider country, and no refinements, either of growing or making, are practised.

Gertrude Jekyll

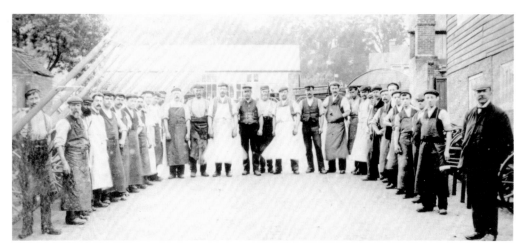

WHEELWRIGHT'S WORKSHOP

THE WHEELWRIGHT'S SHOP

There was no machinery, or at any rate there was no steam or other 'power', in my father's shop in 1884. Everything had to be done by hand, though we had implements to serve machine-uses ill their feeble way. I myself have spent hours turning the grind-stone. It stood under a walnut-tree; and in sunny weather there might have been worse jobs.

Another implement to be turned with a handle was a drill, for drilling tyres for the blacksmiths. To put this round, under its horizontal crank, was harder work than turning the grindstone. Men took turns at drilling, for it was often a long job. I don't remember doing much of this; yet I well remember the battered old oil-tin, and the little narrow spoon, and the smell of the linseed oil, as we fed it to the drill to prevent overheating.

More interesting—but I was never man enough to use it—was a lathe, for turning the hubs of waggon and cart wheels. I suspect it was too clumsy for smaller work. Whenever I think of this, shame flushes over me that I did not treasure up this ancient thing, when at last it was removed. My grandfather had made it—so I was told. Before his time the hubs or stocks of wheels had been merely rounded up with an axe in that shop, because there was no lathe there, or man who could use one. But my grandfather had introduced this improvement when he came to the shop as foreman; and there the lathe remained until my day. I had seen my father covered with the tiny chips from it (the floor of the 'lathe-house' it stood in was a foot deep in such chips), and too late I realised that it was a curiosity in its way.

George Sturt

LEARNING THE TRADE

With the idea that I was going to learn everything from the beginning I Put myself eagerly to boys' jobs, not at all dreaming that, at over twenty, the nerves and muscles are no longer able to put on the cell-growths, and so acquire the habits of perceiving and doing, which should have begun at fifteen. Could not Intellect achieve it? In fact, Intellect made but a fumbling imitation of real knowledge, yet hardly deigned to recognise how clumsy in fact it was. Beginning so late in life I know now I could never have earned my keep as a skilled workman. But, with the ambition to begin at the beginning, I set myself, as I have said, to act as boy to any of the men who might want a boy's help.

I recall one or two occasions when the men smiled to one another, not thinking I should see them smile; yet on the whole most kind they were, most helpful, putting me up to all sorts of useful dodges. The shriek of my saw against a hidden nail would bring the shop to a horrified standstill. When the saw jumped away from the cut I was trying to start, and jagged into my hand instead of into the timber, the men showed rile where my hand ought to have been. Again, they taught me where to put my fingers, and how to steady my wrist against my

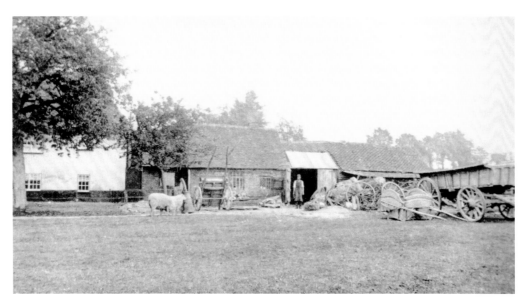

SMITHY, WOKING

knee, for chopping out wedges or 'pins'. The men showed me how to drive in a nail without splitting the board yet without boring a hole for it to start. Wire nails had not then been introduced. 'Rose-nails'—wrought iron, of slightly wedged shape—were the thing. By forcing it in the right direction a two-inch 'cut-nail', as we called this kind, might be driven down to the very head, through inch elm into oak, with proper hammering. If sometimes a nail curled over instead of entering, or if it insisted on turning round so that the board was split after all, the fault was that the hammering was feeble or indirect. The men could not help that. They could not put into my wrist the knack that ought to have begun growing there five years earlier.

This same difficulty in hammering, which I never quite overcame, made me a poor hand at 'knocking out dowels'—another job for boys. A dowel, with us, was a peg holding together the joints of a wheel-rim where the felloes meet. Heart of oak was not too tough for it; in fact, my father, superintending some spoke-cleaving, had carefully saved the very innermost cleft, all torn and ragged, for dowels. About the size and shape of a sausage, they were made by driving prepared lengths of oak through a 'dowel cutter'—a sharp-edged ring of steel set in a block for that purpose, and a man with a heavy mallet could soon knock out a set of dowels. But, in my hand, the mallet was apt to fall a little sideways, so that the dowel, when finally slipping through on to the ground, proved crooked and useless.

Of course I had far too many irons in the fire—that was one part of the trouble. I was trying to learn four or five trades at once; and 'intellect' fooled me by making them look simple. Indeed, so much of hand-work as intellect can understand does have that appearance, almost always to the undoing of the book-learned, who grow conceited. How simple is coal-hewing, fiddling, fishing, digging, to the student of books! I thought my business looked easy. Besides playing 'boy' to the woodmen I went sometimes to help the blacksmith 'shut' a tyre, and I always lent a hand at putting on tyres. Painters there were none, but as paint was used by the wheelwrights after they had finished a job, of course I called in for a little rough painting. I hadn't strength enough in my arm to grind up Prussian-blue for finishing a waggon-body. I knew how to make putty, 'knocking it up' with whiting and oil. I was familiar with 'thinnings' of 'turps', as we called turpentine. I kept watch on the kegs of dryers, Venetian-red, and so on, to see that the paint was not drying on their sides but was kept properly scraped down into the covering puddle of water in the keg.

A number of duties fell on my shoulders in which nobody could guide me in my father's absence. During his illness and after his death I had to be master, as well as boy. Amongst other things was the work of store-keeper. Not only timber, iron and paint were wanted; axles and half-axles known as 'arms' were kept in a corner of the body shop; and in my office, under lock and key, were the lighter kinds of hardware. Many times a day I was

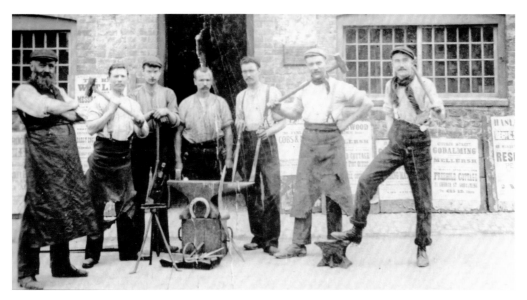

BLACKSMITH'S SHOP, HASLEMERE

called away from my own job, whatever it might be, to get nails, screws, bolts, nuts, 'ridgetie' chains, bolt-ends, 'nut-heads', or what not. Sometimes, with hammer and 'hard-chisel', I cut off lengths of chain for a tailboard, sometimes a longer length of a stouter chain for a 'drag-bat', or of a slighter chain for a 'roller'. It was so small a shop that these interruptions were after all not too frequent. And anyhow I was proud to feel that I was doing what my father would have done.

Whenever a job was finished I went with slate to the men who had taken a hand in it, and wrote down what they had done to it, what materials they had used, and so on. Until I began to know the technical words, and the Surrey dialect of the men too, this was a great puzzle to me. How was I to know that when the old blacksmith spoke of a 'rop-pin cleat' he had meant wrapping plate? or that a 'shetlick' was the same thing that my father and grandfather spelt shutlock in the old ledger?

Of course I had no proper system of account-keeping, or the work could not have been done in the little time I gave to it. Not that I was quite primitive. I was at least a stage beyond the blacksmiths, who weighing scrap-iron for sale (3s. 6d. the cwt. was the price), chalked up the hundredweights on the door until they came to five, and then made a fifth stroke across the other four. I was not quite so bad as this; indeed, I used decimals in checking the invoiced weights of new iron; but for all that, my book-keeping was antiquated enough. It was hardly more elaborate than my grandfather's had been. In normal times, therefore, the office-work can hardly have occupied two hours of the day. The account-books were always at hand. It was quite easy to do all the writing in odd half-hours, so as not to feel office-work irksome at all. Billmaking times of course were busy; yet it was only at Christmas that all the bills were sent out. The idea was that farmers might have money at that season. And in Farnham especially it was worth while to ask for money then—so soon after the hop-fair at Weyhill in October.

GODALMING BLACKSMITH *George Sturt*

CHARCOAL BURNER'S CAMP. WOTTON

CHARCOAL BURNING

One has read the expression 'black as a collier of Croydon', and Camden tells us that the townspeople made 'good chaffer' of 'charcoals' in his time. This once famous industry of Croydon. . . has left its 'ripple-mark' in Colliers' water lane, near Norbury Brook where it flows north and west to join the Wandle.

John Morrison Hobson

BOURNE: A QUAINT AUCTION CUSTOM

A curious custom which obtains in connection with the letting of a piece of land at Bourne, known as 'The White Bread Meadow', was observed this week. The land was let by auction, and at each bid a boy was started to run to a given public house, the land being let to the person whose bid had not been challenged when the boy returned. The money—in this case amounting to (5. 7s. 6d. was partly spent in a bread and cheese and onion supper at a public house, and the remainder in loaves of bread delivered to every house in a certain district of the town.

The Daily Mail, August 1902

THE SQUIRE'S BROTHER

The Limpsfield cricket green makes one of the most picturesque pitches in the county, though the Oxted cricket ground is larger and has finer turf. Mr H.D.G. Leveson-Gower, the well-known Surrey cricketer, is a brother of the present squire. You must pronounce the name Loosen-Gore, if you please, which reminds me of a story told

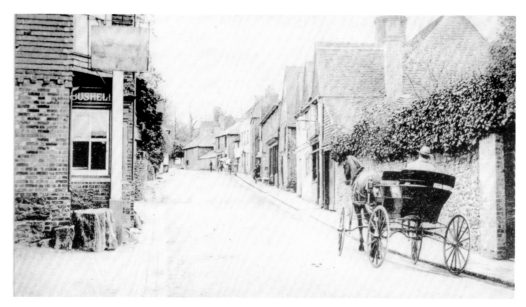

LIMPSFIELD VILLAGE

me when I first came to live in this neighbourhood.

A gentleman who was out shooting with the squire's parry, straying from his friends, lost his way in the moorland district of the Chart. Coming across an old shepherd, he inquired if the old man had seen Mr 'Loosen-Gore' pass by.

'Never heerd tell o' that name about here,' replied the old shepherd, after cogitating over this curiously-pronounced name.

'What!' cried the gentleman; 'never heard of the squire, and you a shepherd on the estate!'

'Why, then you must mean Mr Lev-e-son Gow-er,' replied the astonished shepherd, rapping out the syllables like pistolshots.

F. E. Green

LOCAL DIALECT

Few subjects are more interesting than that of local dialect. It may chance that, as in Yorkshire and in parts of the North of England, it may form a distinct language, unintelligible to any but a native, or it may be as in the South of England that the speech of the common folk, while readily intelligible, is seasoned with a number of dialectal words, some classical, some which were current a century or more ago; all expressive and all worth treasuring up. It can hardly be said of Surrey that it has any dialect peculiarly its own. It is probable that there is no word in use in the county which is not current in Kent and Sussex, while on the other hand, words are in use in those counties which are not current in Surrey, and a careful perusal of the admirable glossaries of the Rev. W.D. Parish, and of Dr Pegge, will establish this fact.

There are not many proverbs specially belonging to Surrey. 'A bright Candlemas Day' is taken to denote a probable renewal of winter, this was the account given to me by an old man:—

'The old folks used to say that so far as the sun shone (the 'o' in the word pronounced long) into the house on Candlemas Day, so far would the snow drive in before the winter was out.' A fine Easter Day is supposed to be followed by 'plenty of grass, but little good hay'; meaning that the summer will be wet. A fine bark-harvest, i.e. fine weather for getting in the bark after the oak 'flawing' is done, indicates fine weather for gathering in the harvest. 'I expect', said a farmer, 'we shall have a shuckish time at harvest, we had it so at bark-harvest, and they generally follow one another:

There is a prejudice against thunder early in the year, hence the saying 'Early thunder, late hunger'. The black-

THAT 'BOY-CHAP'

thorn winter or black-thorn 'hatch' as it is sometimes called, is always spoken of to denote the cold weather which generally prevails about the time that the black-thorn is in bloom. A backward spring is thought to indicate a fruitful season; the common people have this proverb:—

When the cuckoo comes to a bare thorn,
Then there's like to be plenty of corn.

The point from which the wind blows at any quarter day, is supposed to denote that it will remain more or less in the same quarter for the ensuing three months, and the same is said with regard to Kingston Fair Day,

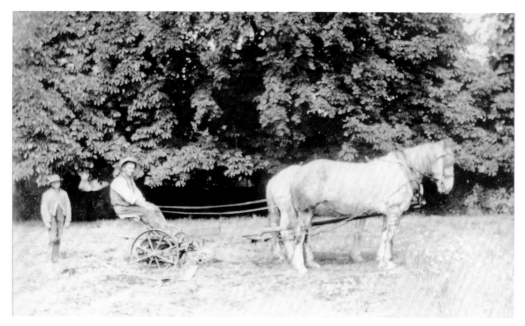

HORSE-DRAWN RAKE, FARNHAM

which occurs on 13th November. A writer in Notes and Queries (vi. s., ii., 406) gives a remark made to him, 'The wind's a-blowing hard from the south-west, and wherever she is this day, she'll stick to all the winter.' The moon is supposed to govern the weather absolutely, the time of day at which it changes is all-important, the nearer midnight the better, the nearer mid-day the worse. The prejudice against a new moon on a Saturday is universal, and finds expression in the following doggrel:—

> Saturday new and Sunday full,
> Ne'er brought good and never shall. (pronounced 'Shull')

Another weather proverb is, 'So many fogs in March, so many frostes in May'.

The 'pig in the poke' is the proverb for an untried bargain, in Surrey as elsewhere; to 'talk his dog's hind leg off' is to be an incessant talker, this proverb exists elsewhere as 'to talk a horse's leg off'. Returning from Croydon one winter night, a remark was made as to the excessive darkness, when the driver replied, 'Aye, so it is, dark as Newgate Knocker'.

'A dark Christmas makes a heavy wheat-sheaf,' i.e. when there is no moonlight at Christmas, it betokens a good harvest. A green Christmas, i.e., one without frost or snow, is said to be followed by a full churchyard, being regarded as unhealthy.

'Deaf as a beetle' does not refer, as might be supposed, to the insect of that name, but is equivalent to 'deaf as a post', 'Beetle' or 'Biddle' being used in Surrey for a mallet.

'Christen your own child first' was the somewhat forcible way, in which a local Poor Law guardian expressed the sentiment that charity begins at home.

'Too big for my fireplace', is equivalent to 'beyond my means'. It was used to me thus, 'Thank you for letting me look at the farm, but I think it is too big for my fireplace.'

An old man who had been neglected by a worthless son, remarked to me plaintively, 'It ain't often that the young birds feed the old.'

Where we should say of an over-busy man that he had 'too many irons in the fire', a Surrey man would say that he had too many 'heats' in the fire. As 'heats' is used here as a substantive, so they use 'hot' as a verb; they say of a thing that they will 'hot' it over the fire.

Granville Leveson Gower

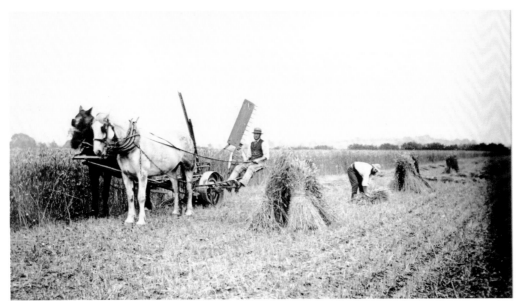

THE SAIL-REAPER, BADSHOT FARM

'LEASING'

Indeed, in these sad days of cheap building, and corrugated iron roofing, and machinery, one looks in vain for many of the lost beauties of country life. Women, gleaning in the harvest-field—'leasing' as they used to call it—are now no longer seen. The pitiless, grasping iron contrivances pick up the stray ears too closely. The mower carrying his scythe is to be remembered only, for he is rarely to be met.

In the older days the wives and children of farm-servants were allowed to glean or 'lease' on the fields of the farm where the father was employed, before the sheaves were carried. If others came who were not entitled to the privilege, they were roped off the field, where it was free of sheaves, by a rope stretched between two horses, and so carried down the field. After the corn was carried, most farmers allowed anybody to glean. The children held the ears on long stalks, in their hands close up to the heads, making neat bundles. The ears on short stems were dropped into an apron pocket.

The corn so gleaned, after being threshed, was ground at the mill free of charge and sent home to the cottages. In a good season the gleaners could usually get enough to last well through the winter.

Gertrude Jekyll

HAYMAKING

Those cheerful gangs of hay-makers and harvesters—are they gone for ever? Let us hope not. What happy and well-earned meals those were that were eaten sitting under the shady side of the hedge bank, where an oak gave wide overhead shelter.

The mower's meals were many and his wholesome drink was much, but he toiled the long day through with all the strength of his body—every muscle in full play.

Often they began work at daylight, and on some farms it was the custom that the man who came first got a pint of ale.

The mowers' regular meals were: breakfast at six, lunch at half-past nine, dinner at noon, afternoon lunch at four, supper at seven, when the farmer generally gave each man a bottle of beer or cider.

A man would mow an acre of hay a day for half-a-crown or three shillings, but he could mow an acre and a half of barley. A first-rate man has mown two acres of barley. Now, an acre of hay cannot be hand-mown under ten shillings.

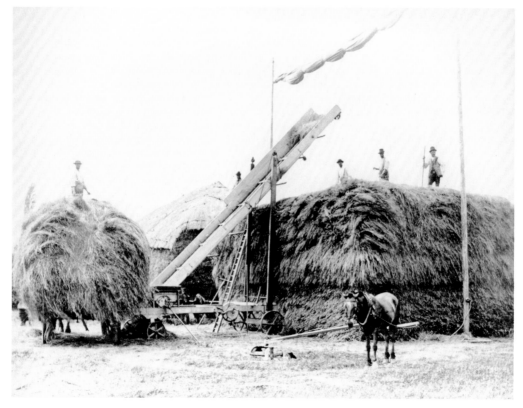

BADSHOT FARM

The drink—beer or cider—was carried in the wooden harvest-bottle—a little barrel strongly hooped with iron. The largest are about ten inches high, and will hold a gallon. Like all good barrels they are of oak, with a projecting mouthpiece, and just above it a hole for the vent-peg. The vent-peg and cork are tied to the rope-handle, so that they cannot go astray; two holes are bored in the base of the mouth-block, through which a cord or leather thong is passed, to carry by.

Gertrude Jekyll

SCYTHES

In the appearance of a scythe—a whimsical friend avers, too fantastically—so slender and yet strong, so graceful, so keen, and so aquiline withal about the nose, there is every mark of the aristocrat; it is the grandee among country tools; an ancient and honourable lineage is betokened in every one of its shapely curves. Upon prongs and forks and shovels you must look with suspicion—there is no telling to what base ends they have been applied. Such things as rakes and hoes you may despise for humble grubbers in the dirt, as they are; even the fag-hook and the bill lend themselves to every hand and lack exclusiveness; but there is nothing common nor unclean about the scythe, which stands apart with a sort of resemblance to the sword of chivalry, as a formidable substitute for which it has in fact sometimes been used.

Without indulging such far-fetched fancies, it must still be owned that scythes have a charm quite singular among tools. Their shape alone might account for it; smooth and sinuous, with deadly possibilities lurking somewhere in their aspect, they do certainly fascinate. It is a severe and simple beauty theirs, as good as that of Greek statues, unspoiled by prettiness, comparable to the exactness of natural things; such a beauty as only generations of single-minded attention to what is fit can give to any human product. But they make an even greater appeal to the imagination than to the sight; for perhaps in all the world there is no other thing so intimately associated with the summer at its best, and its best only. At sight of this tool one does not always think

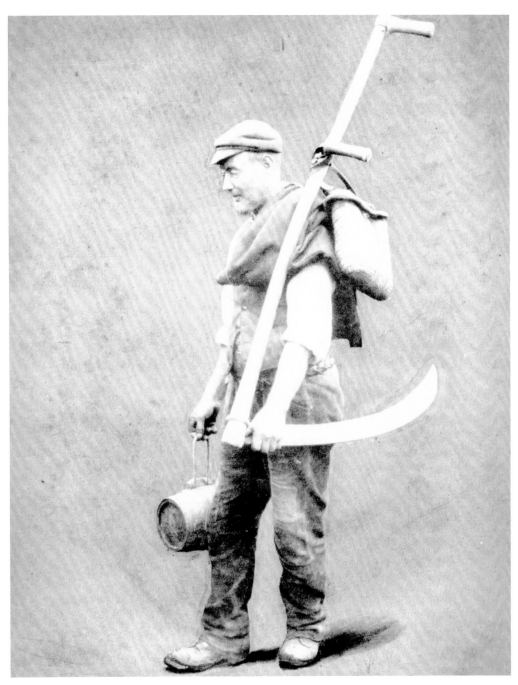

A MOWER

consciously of the deep meadows and the June days, but it is odd if some of their beauty does not find its way into one's spirit. And from the brave English weather that they recall, a feeling of kinship with the generations of men who have rejoiced in it with scythes in their hands is never very far remote. The care they have bestowed, the skill they have expended, upon shaft and blade, and all the queer ideas and traditions that have gathered round the subject, cling to this thing of wood and iron and give it dignity. Whatever one thinks, or hears said, about a scythe is always agreeable.

George Sturt

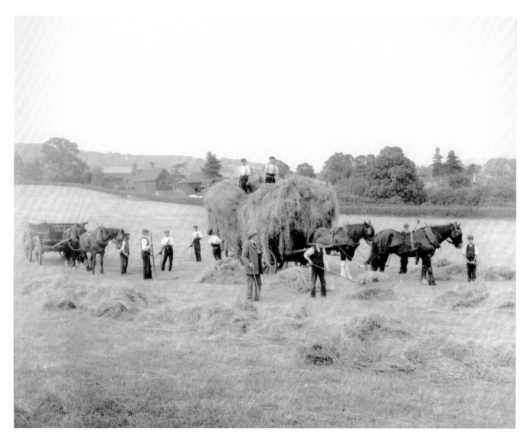

MILTON FARM, WESTCOTT

THE HAYMAKER

I turn into my next inn with unusual hopes. For it was here some years ago that I met for the first time a remarkable man. It was nine o'clock on a late July evening, and the haymakers, only just set free, came stamping into the bar. The last wagonload stopped at the door while the red-whiskered carter stood, one hand on the latch, and drank his pint before leading his horses into the stall. After the haymakers, in their pale corduroys and dirty white slops, came a tall, spare, shock-headed man, not recently shaved, dressed in grey—grey coat, grey breeches and stockings, and a tall, hard felt hat that was old and grey. He called for sixpenny ale, and wiping the hay dust from his neck sat down beside me.

No, he is not here today. Perhaps he will never get out of London again.

I asked him the way to the nearest village, and whether a bed was to be had there. He answered that it was some way off—paused, looked at me, drank from his tankard—and added in a lower voice that he would be glad if I would come and share his place. Such an unusual invitation enforced assent.

A quarter of a mile down the next by-way he opened a little oaken gate that slammed after us, and there, in a corner of a small, flat field, was his sleeping place, under an oak. Would I care to join him in fried bacon and broad beans and tea at six next morning?

He lit a wisp of hay and soon had a fire burning, and brought over some hay and sacks for the second bed. The lights of the farm-house shone on the other side of the little field behind lilac bushes. The farmhouse pump gave out a cry like a guinea fowl for a few minutes. Then the lights went out. I asked the name of the farm and he told me.

'I come here almost every summer for the haymaking,' he said, and detecting my surprise that it was not his first year of haymaking, he continued:

'It is my tenth summer, to be exact.'

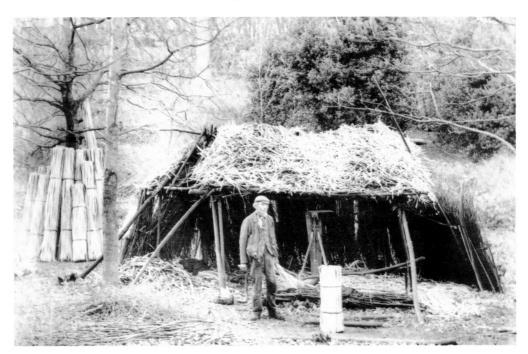

HOOPSHAVER, WOTTON

He was a man of hardly over thirty, and I noticed that his hands, though small and fine, were rough and warty and dark. Thoughtlessly I remarked that he must find the winter hard if he travelled like this all the year round.

'Yes,' he said, with a sigh, 'it is, and that is why I go back in the winter; at least partly why.'

'Go back—?'

'Yes, to London.'

I was still perplexed. He had the air of a town-bred man of the clerkly class, but no accent, and I could not think what he did in London that was compatible with his present life.

'Are you a Londoner, then?'

'Yes, and no. I was born at the village of—in Caermarthenshire. My father was a clerk in a coal merchant's office of the neighbouring town. But he though to better himself, worked hard in the evenings and came to London, when I was seven, for a better-paid post. We lived in Wandsworth in a small street newly built. I went to a middle-class school close by until I was sixteen, and then I went into a silk merchant's office. My father died soon after. He had never been strong, and from the first year's work in the city, I have heard my mother say, he was a doomed man. He made no friends. While I was young he gave up all his spare time to me and was happy, wheeling me, my mother walking alongside, out into the country on every Sunday that was not soaking wet, and nearly every Saturday afternoon, too.'

Edward Thomas

COPSE-CUTTING

Copse-cutting is one of the handy labourer's winter harvests, and is done by piecework. One of the industries that grew out of it, namely hoop-making was described at some length in *Wood and Garden*. It is the making of hoops for barrels and packing-cases; hoops shaved on both sides and made up in neat bundles of standard lengths. The shavings make a capital and durable thatch. Hoop-making, which is still carried on in the woods of the district on a rather large scale, is probably not an ancient industry. It must have grown with the modern facilities for communication, for the largest and longest of the hoops go to the tropics for sugar hogsheads.

Gertrude Jekyll

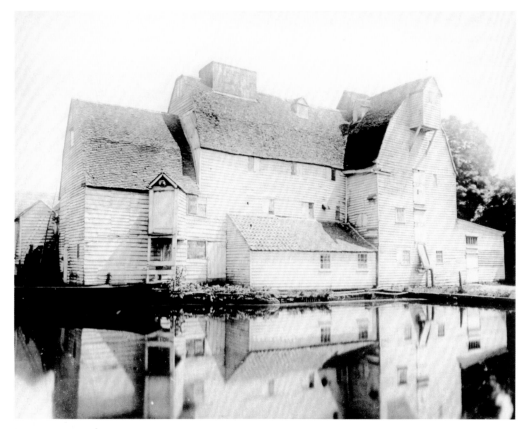

PYRFORD MILL

THE WATERMILL

The water flour-mills are usually buildings of some antiquity, and nearly always of interest in some way or other. Indeed, the mere fact of the placing of the mill, with its pond above and its stream below, and the working of it—the water dashing in the great wheel, the sound of the old-time mill machinery, the constant vibration as of something alive (some sort of plodding, lumbering, good-natured, meal-producing monster, fed and guided and controlled by the careful miller)—the pleasant smell, the light dimmed by the floating floury particles—all these sights and sounds and impressions make a water corn-mill a place where the imagination is stimulated to something akin to a poetical apprehension of the ways of the older industries that have gone on almost unchanged for a thousand years.

The mere fact of the change of level, the building standing on the higher ground on the side of the pond-head, with the quiet expanse of water, and coming down below to within a few feet of the level of the rushing tail-race; necessitating some kind of steps outside; this in itself compels the builder to ways of treatment that can scarcely fail to have pictorial value. And when these old places were built, and the builder of each mill used the material to his hand in the local way, just enriching it here and there by some simple means, as in the brick cornice in whose joints the polypody fern has found a home, and in the toothed string-course above; looking at the building one is filled with the comfortable conviction, that of its kind, and for its place and purpose, it could scarcely have been better done. The stone of which this mill-house is built is not quite the same as the Bargate stone of the sandy hills, though it is a product of the same formation. It comes from nearer the Weald, and is quarried in larger blocks. Especially with this stone, but often also with the usual Bargate, local custom decorated the rather wide or uneven mortar joint with small pieces of the black iron-stone. The bricklayers call it garoting or garneting; there seems to be no general agreement as to the exact word.

Gertrude Jekyll

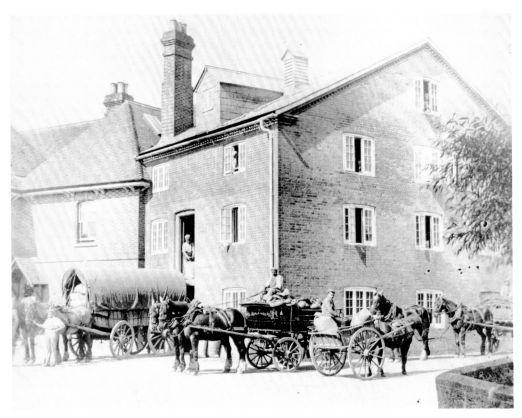

FRENSHAM MILL

THE OLD MILLER

We have walked this evening down to the old mill by the river Mole. I have, not unnaturally, a great affection for a watermill, as I passed all my childhood so close to its thumping mysteries, and my bedroom as a girl was just above the rushing mill-tail, where the brown trout lay under the laurels. My old mill is all modernised and altered now, while here the miller says with pride 'I have been here fifty-two years, and I grind the flour with the old stones—no modern china rollers for me'. We buy his flour and his wholemeal and his bran. The latter is what we really went down to fetch, as one of my nieces is fond of bran water. This wildly stimulating beverage—far too much a tonic for my age—is an American drink. You pour cold water on two handfuls of fresh bran, let it stand for four hours, and then pour it off. It is supposed to contain some of the phosphates in the husks of the wheat, and consequently has much of the nourishing qualities of brown bread.

Mrs C. W. Earle

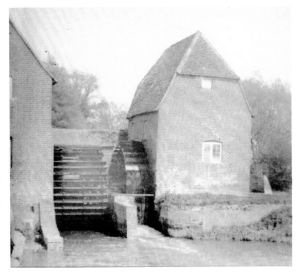

COBHAM MILL

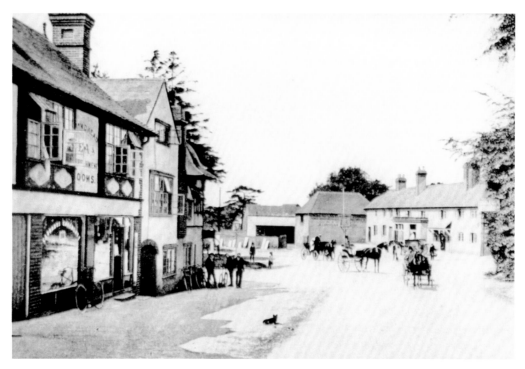

HUTS CORNER, HINDHEAD

A SURREY FARMER

You enter the village by passing the Reading Room, where we used to sit in solemn conclave discussing the affairs of the parish, under the chairmanship of an old man, now passed away, who was as interesting a type of an old Surrey farmer of the old school as you could possibly wish to meet. He had a rubicund countenance, with patriarchal white whiskers. There was about him an air of genial benevolence which made ladies exclaim, 'What a dear old man!' But when you came to examine his blue eyes closely you detected a foxy look in them which did not harmonise with the general benevolence of his aspect.

He was not devoid of brains, and had fully developed the countryman's cunning, which the townsman so often fails to understand, as it is masked by an apparent simplicity of character. This old man ruled the neighbourhood through his farming family connections. He was the cleverest member of the oligarchy and when we met on the first night of the assembling of the Parish Council after a poll, one of his henchmen proposed that he should be our co-opted chairman.

Then ensued an amusing scene. The old farmer's son was sent to convey the news to his father. He returned with the announcement that his 'father said he had taken off his boots now, and would rather be excused from coming round'. Thereupon another messenger was sent from the Council to convey the gravity of the situation, while we looked at one another in stolid silence. Eventually the old farmer turned up, and was humbly requested by his supporters to take the chair, though he had made it a boast that he had never read the Parish Council Act. Really there was no need that he should, since he never intended that anything should be done.

He was also a member of the Rural District Council so that, whenever the Parish Council was rash enough to propose, at my suggestion, a housing scheme, he made sure that when the resolution reached the Rural District Council it languished under the table.

When this old gentleman died there was a great procession to his funeral. Officials of the District Council and relations of all kinds attended in large numbers. A tragi-conic incident took place across the open grave which I really must relate. The Master of the Workhouse stood on the one side of the open grave, and a deeply-mourning nephew on the other, and over the grave these words were solemnly spoken: 'You can sell them pigs.' It was the deeply mourning nephew speaking to the Master of the Workhouse!

AN OLD FARMER

I remember how a member of this oligarchy once regretted to a farmer friend of mind that farming was not like it was in those good old days when you could 'chuck a blooming great bucket of water into a churn of milk and no one be any wiser.

F. E. Green

WHITE HILL, BLETCHINGLEY

MEMORIES OF THE SURREY HILLS

As I said before, my knowledge of Surrey Hills dates back from a considerable period of time—when the mansions of the old gentry of the land, the owners of the soil,—with their interiors furnished with solid oak and mahogany, made by hands that loved their work and did it conscientiously, and their walls covered with paintings representing some incident or other of outdoor natural life rather than the so-called pictures of genre or the sickly sentimentalisms of the more aesthetic world,—were the only houses to be seen. And these stood far apart, nestling in the rich woodlands within sight of a glimpse of thin blue smoke, curling up from some glades where those who worked on their estates lived in their substantial old cottages, that had more solid oak timber in one of them than there is in a dozen of those built at the present time. They were the only signs of human life that the wanderer would see when I first came to these parts of Surrey; but time brings changes—nearly all the old gentry have gone, to the sorrow of some of us, for they were ladies and gentlemen in the fullest sense of the word. A few old families remain, bearing justly honoured names, but these might be counted on the fingers of one hand, I believe. With the old families, their old retainers the woodmen and their 'post and tan' cottages have passed away. They were a hard-handed folk, but kind and homely of speech, themselves nature's gentlemen. I have wandered many a day long with some of them, but they are now nearly all laid to rest in the quaint churchyards of the different hamlets, where they lie covered with what the foresters call their 'daisy quilts'.

Loyal henchmen I knew them to be, to a man; their regard for their employers was very genuine. One of them observed to me once, after a change of owners had taken place, 'I'd sooner hev the old Squire give me one o' his jacketin's when summat had riled him a bit; massy alive! he could put it out,—'twas a real pleasure to hear him, he did rap it out so. But Lor' bless ye! all as ye'd got tu du was to stan' an' hear it all, an' say nuthin'; fur when he'd said it he'd walk away, and presently, mind ye, he'd cum back an' he'd say, "Tom, this ere damned gout makes me say things as I didn't ought to; here's half-a-crownd fur ye; ye get on with yer work." Hap' he'd had a word or two indoors that mornin'; bless ye! they has a rumpus, in the shape o' a word or two, now an' again, same as we has, and when they's had their say they likes one another all the better fur it, that's my 'pinion on it. Most menjous high spirity folks wus the old master and the missus; but oh, warn't they real good uns to all the likes o' we! I'd sooner hev a jacketin' from th' old Squire three times a-day than I'd hev a gold suvrin from this un. I puts up with un till I gits summat else tu du; when I gits that I leaves he quick.'

Old Tom's literally recorded declaration of his sentiments expresses the feeling of the few old woodmen's

families that now remain on and about the hills. Modern mansions have been built where some of these older ones stood, or near to them—buildings of ferociously glaring red bricks and tiling, strongly relieved by the white quarterings now so very prevalent in mansions of this particular style. Time will soften the glaring tones—the sooner the better, I think, for they flash out from the surrounding woodlands, reminding me always of those scarlet fungi, of wonderful properties for those who are in the secret, that spring up, happily few and far between, in the fall of the year from the turf at the foot of the trees.

Denham Jordan

ACKNOWLEDGEMENTS AND SOURCES

ACKNOWLEDGEMENTS

I wish to acknowledge the help, advice and support that I have received from the following individuals and institutions in the compilation of this book. Without their encouragement and knowledge, so willingly shared with me on every occasion, this publication would not have been possible.

The County Archivist, Dr D. B. Robinson and the staff of Kingston and Guildford Record Offices. The Curator and staff of Guildford Museum. The staff of the Guildford Institute. The staff of the Surrey Archaeological Society. The staff of the Local Studies Centre, Guildford, especially Mr John Janawav; Senior Librarian, for personally reproducing copy photographs. The Curator and staff, the Royal Botanic Gardens, Kew. The London Borough Of Sutton, especially Ms Julie Broughton, Assistant Heritage Office. The Borough Librarian and staff of the London Borough of Merton (Education K Leisure Department). Richmond-upon-Thames Library Service and Mrs D. Jones. Southwark Council and Ms Nicola Smith, Librarian. Lambeth Archives Department and Mr J.A. Newman, Archivist (Libraries & Arts Service). Kingston Museum and Heritage Service and Mr Tim Everson, Local History Officer. Elmbridge Borough Council and Elmlbridge Museum, also Ian Platford, Assistant Manager of the museum. The Wandle Industrial Museum and Mr Andy Vail. The Dorking & District Preservation Society and Miss Doris Mercer FSA, Curator, Dorking & District Museum. Godalming Museum Trust, Ms Ruth Watson, Museum Education Officer and staff. Waverley Borough Council. Leatherhead and District Local History Society and Mr J.A. Club. Shere Museum and the Curator Mrs Elizabeth Rich, also Mrs Margaret Elston. Spelthorne Museum and Nick Dollard. The Museum of Farnham for the use of photographs from the John Henry Knight collection. Bexhill Museum and the Curator, Miss Brenda Mason. Hastings Museum and the Curator, Mrs Victoria Williams, for use of the photographs from the George Woods collection. Brion Purdey and the staff of the Hastings Central Library. The staff of the Bexhill Library. Mrs Julie Harris for photographs from her family collection. Mr Chris Shepheard for photographs from his own collection. Mr Keith Harding for photographs from his own collection and also photographs by Walter J. Rose (1857–1954) of Westcott, Surrey from the 'Recollections' series and printed from the original glass-plate negatives (copies available from Goodness Gracious, Jayes Park Courtyard, Lake Road, Ockley, Surrey RH5 5RR). I am also deeply grateful to Miss Parker for permission to use extracts from her late father's book Highways mid Byways in Surrey by Eric Parker. While every effort has been made to contact all copyright holders, both authors and publishers, in some instances this has proved impossible and to them I apologise.

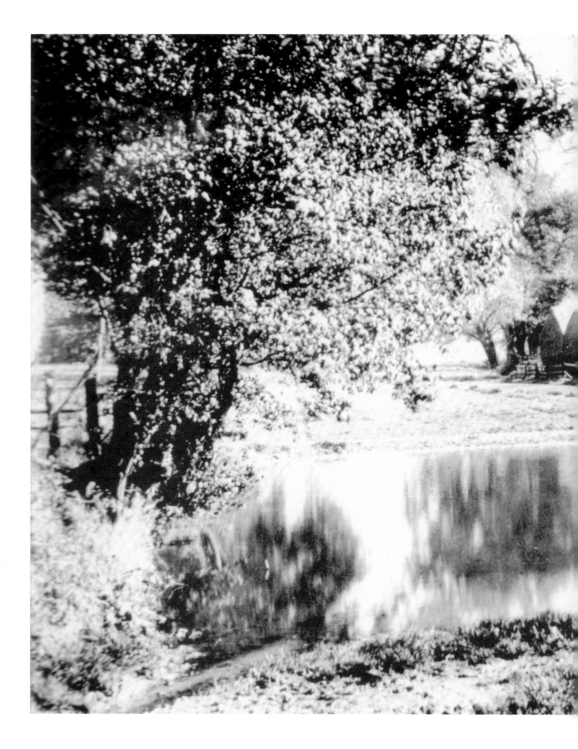

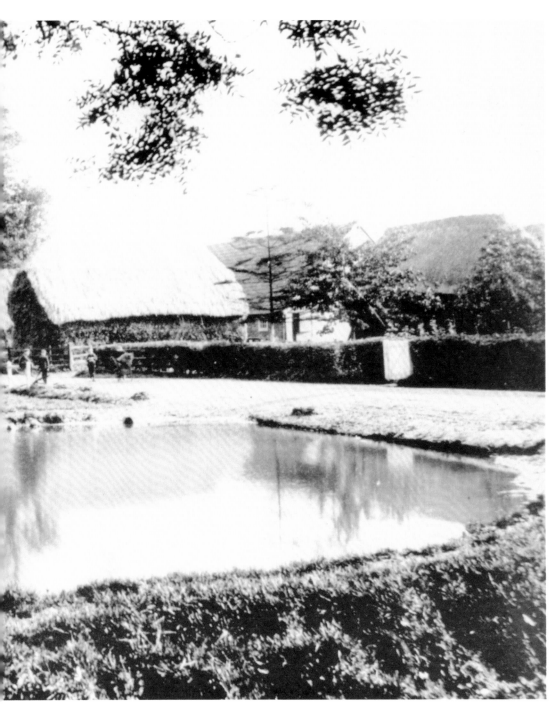

ALBURY FARM AND POND

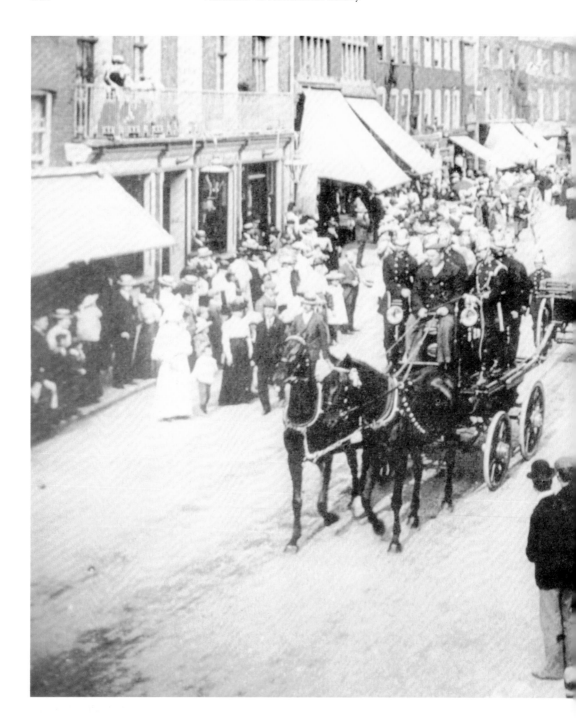

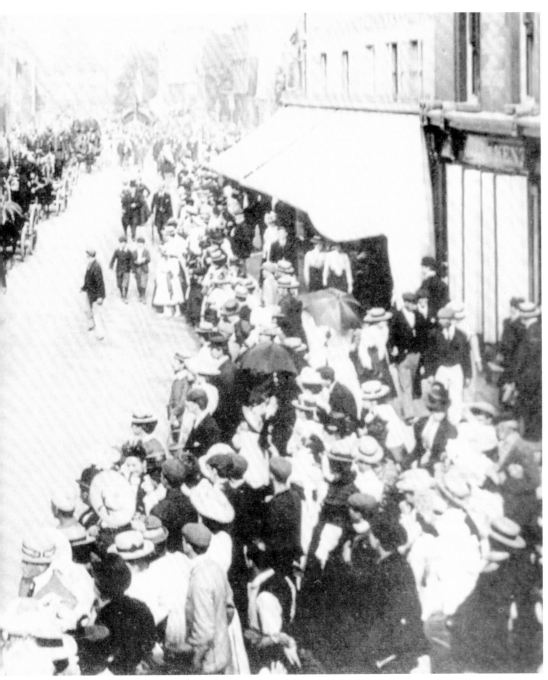

STAINES HIGH STREET

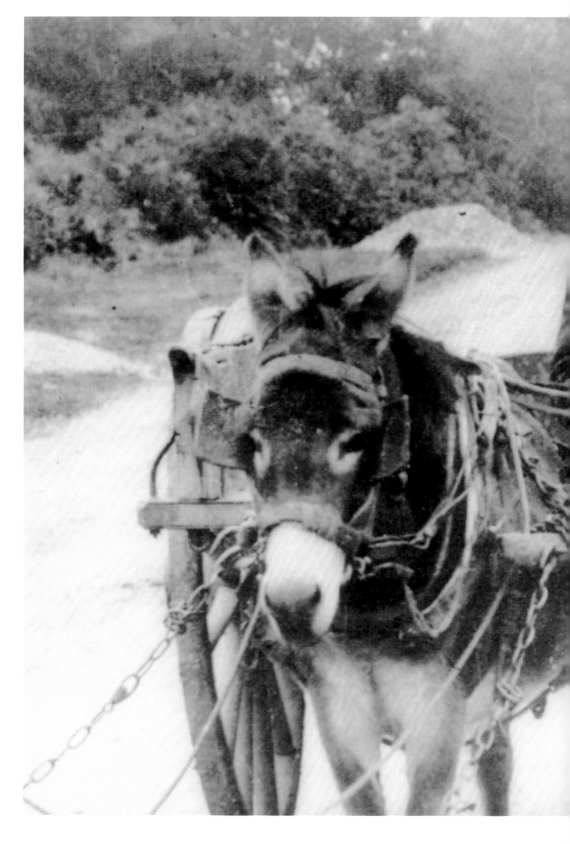

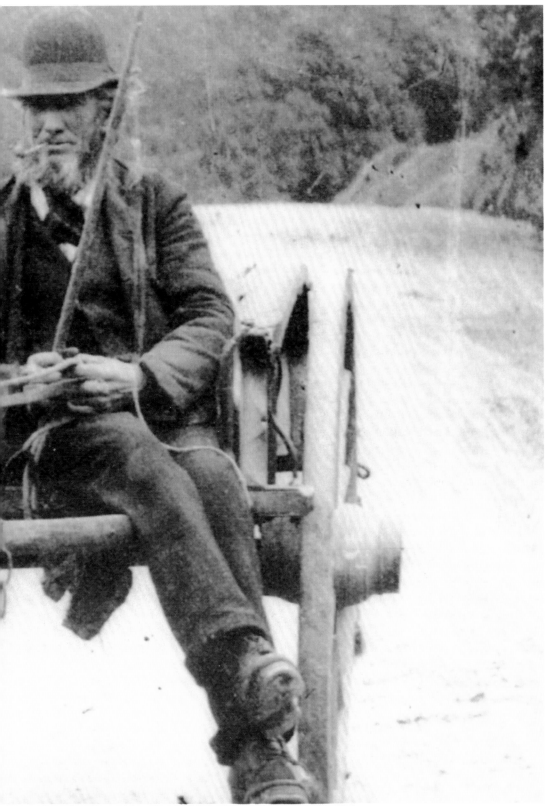

THE CARRIER